THE KENT COAST: GRAVESEND TO MARGATE

THROUGH TIME

Anthony Lane

AMBERLEY

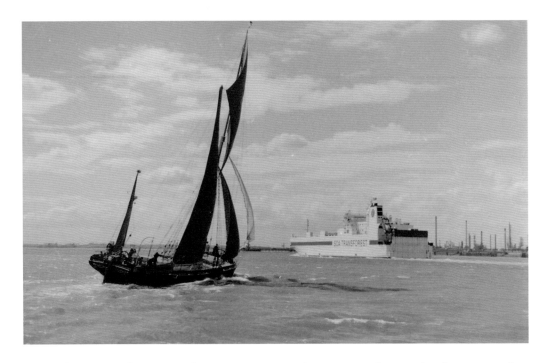

Despite being a modern image, this picture captures the immense changes that have occurred to commercial shipping over the last 100 years. The 1901 sailing barge *Gladys*, tacking upriver in Sea Reach towards the end of a Thames match, is overtaken by Gorthon Lines' 20,000-ton forest products carrier *Ortviken*, built in 1996. In days gone by Thames barges supplied the estuary ports, large and small. Where no harbour existed, they were able to run up on the beach and discharge their cargoes into horse-drawn carts brought alongside at low water. They carried literally every cargo imaginable: coal, flour, sugar, tar, beer, hay, bricks, refuse, cement and numerous others, most often with a crew of two. (A. L.)

First published 2014

Amberley Publishing
The Hill, Stroud
Gloucestershire, GL5 4EP

www.amberley-books.com

Copyright © Anthony Lane, 2014

The right of Anthony Lane to be identified as the
Author of this work has been asserted in accordance
with the Copyrights, Designs and Patents Act 1988.

ISBN 978 1 4456 3996 3 (print)
ISBN 978 1 4456 4007 5 (ebook)

British Library Cataloguing in Publication Data.
A catalogue record for this book is available from
the British Library.

Typeset in 9.5pt on 12pt Celeste.
Typesetting by Amberley Publishing.
Printed in the UK.

Introduction

This volume briefly overlaps the area covered in my earlier book, *Thames-side Kent Through Time*, by starting at Gravesend, but continues afterwards along the north Kent coast as far as Margate, embracing the Hoo Peninsula, the isles of Grain and Sheppey, Faversham, the historic port of Whitstable, the relatively recent resort of Herne Bay and the ancient Roman settlement of Reculver. Bordered to the south by the Swale, only Sheppey remains an island. Yantlet creek, which separated the Isle of Grain from the Hoo Peninsula, and the River Wantsum, which isolated Thanet, have become little more than ditches in places. Both were navigable in earlier years.

Passing from the Thames to the Medway, Sheerness naval dockyard served the fleet for almost 300 years. The naval station at the Nore became an important command before the naval mutiny of 1797 and it continued to be in later times of conflict. Moored hulks of obsolete 'wooden walls' for many years provided accommodation for the dockyard personnel, later becoming 'receiving' ships for those seized by the press gangs and also prison ships for those taken in foreign conflicts, just as Charles Dickens chillingly describes in *Great Expectations*.

After the Dutch raid of 1667 the defences of the Medway were strengthened and further improved from the Napoleonic wars up to the Palmerstone era, when the final fort at Garrison Point was constructed. During the same period the Coast Blockade attempted to counter the efforts of the smugglers. Famous events in the past include calls by Brunel's incredible SS *Great Eastern* to collect cable for the Atlantic telegraph, visits which drew many sightseers round from the Thames on excursion steamers. Queen Victoria left on the royal yacht from Port Victoria pier on a number of occasions. On the negative side, there was the disastrous explosion of the minelayer *Princess Irene* in Saltpan Reach in May 1915. After its closure in 1960, the naval dockyard was developed as a commercial venture importing forest products, fruit and motor vehicles but Peel Ports, the current owners, are now looking for further ways to develop the land.

Nearby Queenborough, with its royal castle, demolished long ago, later briefly became a cross-Channel port and in the twentieth century an important manufacturing centre. One of the first commercial enterprises beyond fishing, farming (and smuggling) was the less than sweet-smelling Sheppy Glue and Chemical Works, established by John Stevens in 1848, which lasted until recent times. However, the new century saw Settle, Speakman's coal washing plant; the Canning Town glass bottle factory; and Alfred Johnson & Sons (later Doulton's) pottery, manufacturing sanitary ware, arrive and expand rapidly; the bottle kilns of Johnson's were reminiscent of the Potteries from where they originated. All these have now closed, but relative newcomer Abbott Laboratories, successful manufacturer of pharmaceutical products, has recently been taken over by Aesica. Eastchurch airfield, to the east of the island, was visited by Orville and Wilbur Wright and was significant in the development of early naval aviation. It is now the site of several prisons.

The earlier sparsely populated Isle of Grain became the site of a major oil refinery in 1952; it closed around 1982 but some tanks were retained for oil storage. More recent arrivals have included the Thamesport container terminal, built on part of the refinery site; Foster Yeoman, who import

stone from Glensanda in Scotland; the National Grid LNG gas storage facility; and the redundant Grain power station, all of which appear almost as one continual industrial estate. The controversial coal-burning Kingsnorth power station further upriver closed in December 2012.

Thames spritsail barges were the main means of transporting cargoes locally for more than two centuries, being commonplace in the ports described, and beached elsewhere when necessary to discharge directly into carts drawn alongside at low water. A contrasting variety of the vessels that have visited the river in more recent years are shown with a selection of the personnel both afloat and ashore who ensure that these often very large ships navigate the coastal and river waters in safety, given that the wreck of the wartime ammunition ship *Richard Montgomery* lies very close to the Medway approach channel.

Further east lie Faversham and Whitstable, small ports with long histories that never became significant industrial centres. Faversham is best remembered for explosives manufacture, small-scale shipbuilding and brewing, but only the brewing survives, Shepherd Neame remaining buoyant after more than 300 years. Whitstable has always been associated with its oysters, and as the terminus from 1830 of the 'Crab and Winkle Line' that transported away coal brought in from north-east ports. It was also the railway that ensured the growth of the resorts and eventually served all the other commercial quays, whether at Gravesend, Queenborough or Ridham Dock. Some were private, such as the extensive network operated by Bowater's paper mills between Sittingbourne and Ridham, part of which is now the Sittingbourne & Kemsley Light Railway. As the roads improved and cars and lorries gradually became more common, the branch lines declined. Today cars clog every street, making some comparative views with the same area in Edwardian times impossible to achieve. Nowadays passenger travel from the Kent ports by sea to London or elsewhere has almost vanished.

Herne Bay, the newest of the Kent resorts, had developed from the village of St Augustine's to a seaside town by 1832. The completion of a long pier and prestigious hotel helped to divert some of the enormous flood of visitors travelling by sea from London to Margate, Broadstairs and Ramsgate. Stagecoaches also ran regularly from there to Dover, thus allowing cross-Channel boat passengers to avoid the rough seas often encountered around the North and South Forelands. Barnes Wallis attended the trials of the bouncing bombs used to breach the German dams in 1943 further down the coast at Reculver.

Another area of growth in the nineteenth century, particularly at the eastern end of Kent, was the convalescent home. Whether to improve the health of railway workers, exhausted maid servants or those suffering from tuberculosis and other ailments, establishments offered very reasonable terms due to benefactors as disparate as friendly societies, private hospitals and workhouses.

Away from the towns, the coast has numerous charms: the crumbling red clay cliffs of Sheppey, the lonely salt marshes of the Swale, the yellow deposits of Bishopstone Glen near Reculver and the white cliffs of Thanet. Farmland and rich nature reserves often separate the populated areas but from Minster to Leysdown on Sheppey, west of Whitstable, and at Reculver, coastal holiday home parks have taken over in profusion.

And so to Margate, popular holiday resort of many years that has now fallen on more challenging times, its harbour largely forsaken. The town has become much more ethnically diverse in recent years. I have described it fully in my book *Isle of Thanet Through Time*.

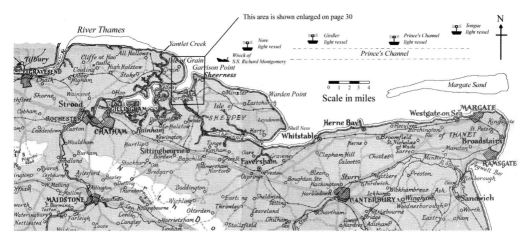

The north Kent coast is shown here with the major towns and other points of interest relating to the navigation of the offshore waters. The 50-mile voyage to Margate by paddle steamer was popular in the nineteenth century, allowing Londoners to take sea bathing holidays. Even in the eighteenth century and earlier, London being the largest port in the empire meant the offshore waters were crowded with shipping.

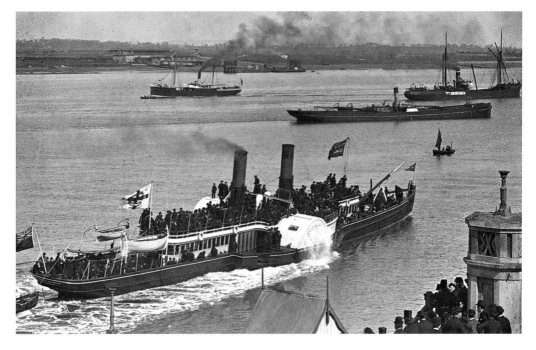

The paddle steamer *Albert Edward* of 1865 embarks on a journey downriver from Rosherville pier, Gravesend, in the later years of the nineteenth century. A sister of the ill-fated *Princess Alice*, and with a passenger license that only allowed her to sail as far as Sheerness, the ship still enjoyed great popularity until she was broken up in 1888. (Kyles)

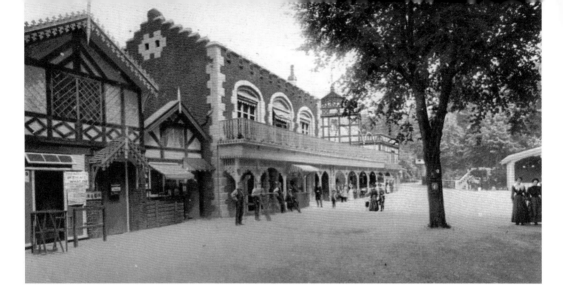

Established in a chalk quarry, Jeremiah Rosher's 17-acre Rosherville Gardens at Northfleet remained popular for almost the entire reign of Queen Victoria. Such was the quality of landscaping and variety of attractions that very large numbers attended, the buildings also creating interest. The Baronial Hall and restaurant, close to the Bijou Theatre, are shown here in the gardens' later days.

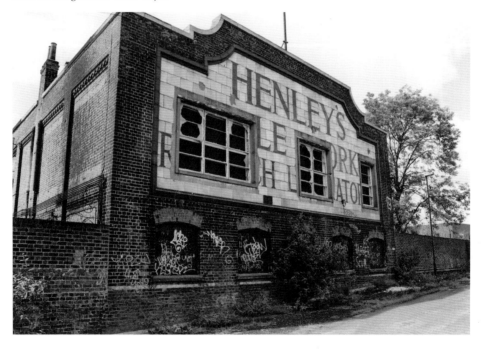

Re-opened in 1903, the gardens struggled on for a further ten years but war finally closed the gates. In 1924, W. T. Henley's purchased 5 acres in order to extend their cable works, followed by the rest of the Gardens in 1939. AEI later purchased Henley's but the original name still adorned the ruins of their research laboratory in 2011. With increasing imports, many cable works closed, Henley's being no exception. Today, the site of Rosherville gardens once again lies derelict but efforts are being made to restore the bear pit. (A. L.)

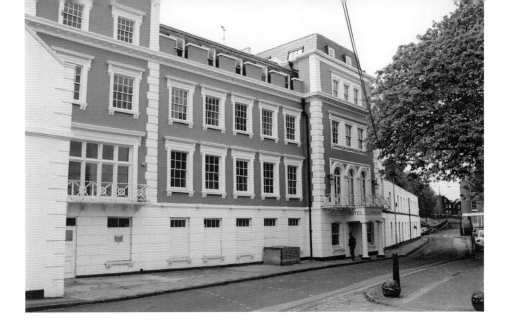

The building in Royal Pier Road now known as the Clarendon Royal Hotel, part of which dates from around 1665, was constructed for the Duke of York, later King James II, when he was Lord High Admiral of the Navy and Lord Warden of the Cinque Ports. Whether he ever lived there is uncertain but the building remained as military quarters until around 1842, when it became a hotel to cater for visitors to Rosherville Gardens. In 1863 the Prince of Wales (later King Edward VII) stayed there while awaiting the arrival of Princess Alexandra at Terrace Pier. Closed in 2004, it has recently been extensively renovated, re-opening in 2010. (A. L.)

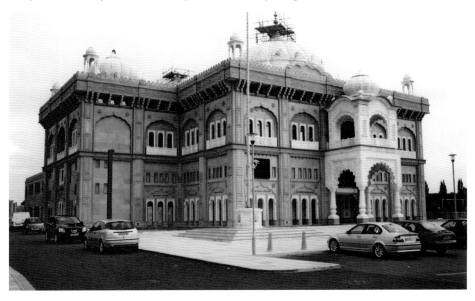

Much more recent is the Sikh temple or Shri Darbar Gurdwara in Gravesend, also officially opened in 2010, the £12 million cost of which was raised by the local Sikh community. Commenced in 2002, it includes a kitchen, lecture theatre, library and crèche and can accommodate 1,200 worshippers. Local architect Teja Singh Biring employed stonemasons from India to work with granite and marble in the construction of this truly remarkable building. (A. L.)

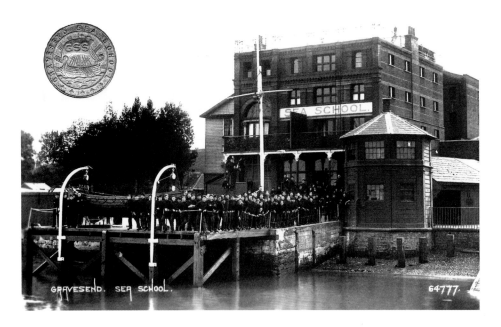

Situated immediately downriver from Royal Terrace Pier, the Gravesend Sea School had its training vessel *Triton* moored offshore, and also the *Vindicatrix* at Sharpness. It was previously the site of the Commercial Hotel and between its formation in 1918 and its relocation in 1967 it trained many deck and catering boys for the merchant navy. *Inset:* A Sea School badge compliments this picture of a group of cadets assembled on the boat-launching platform.

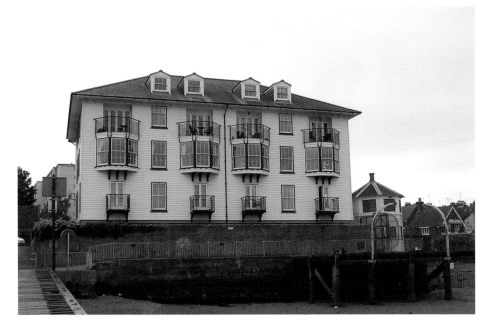

Modern buildings now occupy the site but strangely the boat launching davits, seen on the left in the picture above, seem to have been reluctantly preserved, appearing to the right on this recent picture, and close to the Custom House slipway. (A. L.)

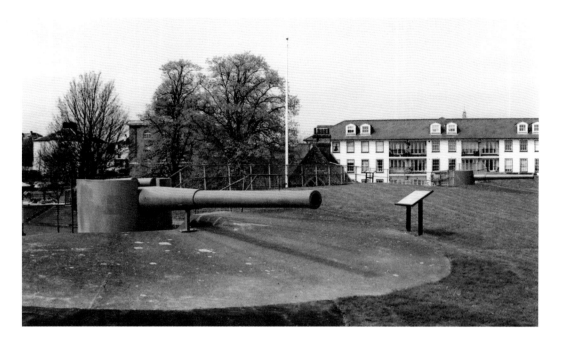

Above: Commenced in 1781, New Tavern Fort was completed by 1795, replacing an earlier Tudor blockhouse. Its name was taken from the New Tavern Inn, on whose gardens, bowling greens and orchards the fort was built. When the French posed a new threat in 1848, it was re-armed with 32-pounder traversing guns but never saw action save to warn vessels that avoided Custom House demands. The fort and the adjoining Gordon Promenade provide admirable views of the River Thames. (A. L.)

Right: Included because of its importance and close proximity to Gravesend, Tilbury Fort on the opposite riverbank has a longer and more notable history, largely as it was the place where Queen Elizabeth I marshalled her army and gave her immortal Armada speech in 1588 while staying at nearby Belhus Park. The earliest forts at Gravesend and Tilbury were built by her father but, after the Spanish invasion threat, they declined. However, an impressive new plan for Tilbury was approved by Charles II in 1670. Construction commenced the same year and the fort was completed by 1683, the best example of a moated, bastioned fortification in England. Two entrances were provided, the most important being the highly decorated Water Gate shown here. (A. L.)

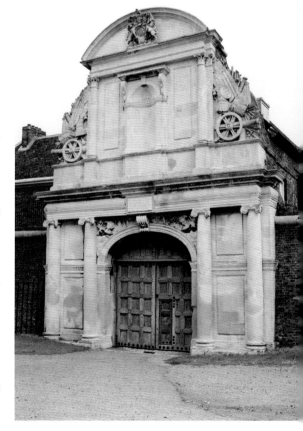

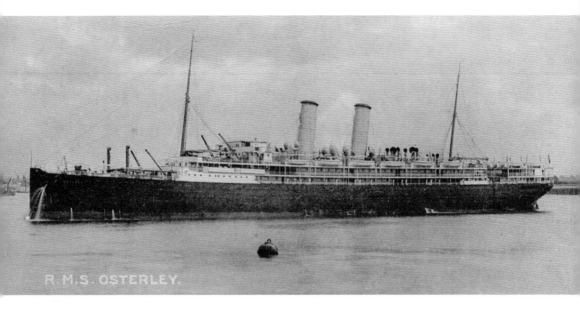

R.M.S. OSTERLEY.

A selection follows of the various ships that have passed Gravesend over the past century. Orient Line steamers were regular visitors to Tilbury Dock and are represented here by RMS *Osterley*, Clyde-built in 1909 as one of five similar ships. She had the distinction of colliding with a Russian steamer on her maiden voyage but, once repaired, survived the First World War. Elevated to cruising to Norway in her final years, she was scrapped in 1930. (London Stereoscopic Company)

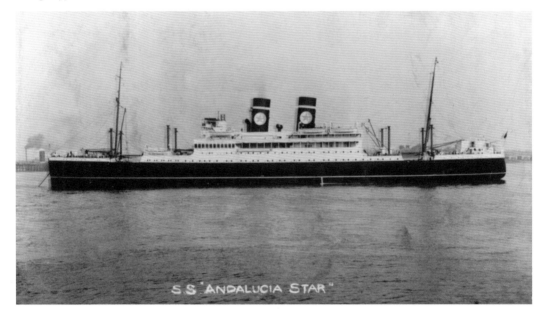

S S "ANDALUCIA STAR"

Built almost 20 years later and also one of five sisters, the Blue Star intermediate passenger liner *Andalucia Star* maintained the twin-funnel layout. They made regular round voyages to Buenos Aires from February 1927, returning with frozen meat. Sadly all were war losses, the *Andalucia Star* being sunk by a U-boat 130 miles west of Freetown on 6 October 1942. (H. Y. Scott, Gravesend)

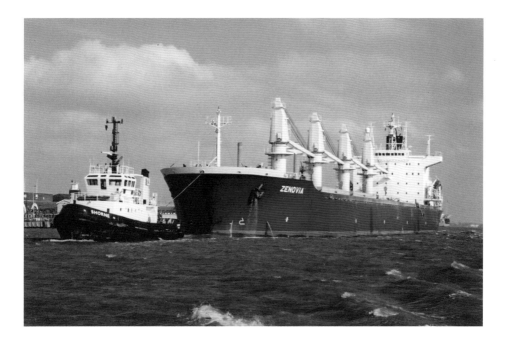

Many bulk carriers nowadays visit the Thames. This example, the 26,000-ton *Zenovia*, built in 1992 and owned by the Byzantine Maritime Corporation of Athens, flies the Maltese flag. She is seen here bound inwards past the Tilbury Cruise Terminal with Adsteam's ex-Dover tug *Shorne* made fast to her bow. (A. L.)

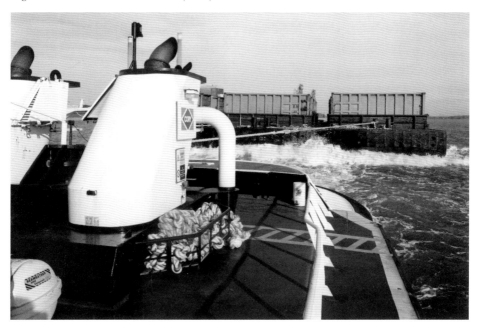

Cory Environmental's tug *Regain* tows a group of barges with empty refuse containers back from the Mucking dumping site to the London waste depots in 2009. Since the establishment of the incinerator at Crossness, which produces energy from waste, the Mucking site has been closed and only residual ash is still brought down river. (A. L.)

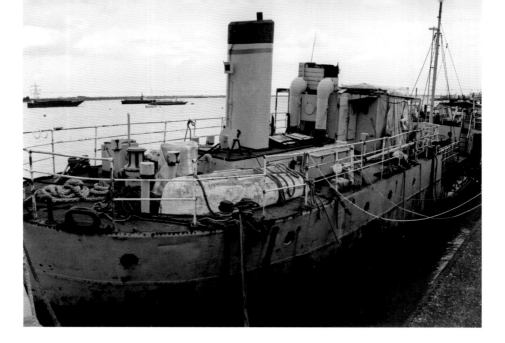

An unusual use for a tanker has been made of this 100-foot ex-Admiralty self-propelled lighter, *C.632*, which served as a lubricating oil carrier until 1977 but afterwards became a houseboat. As such, it was moored just east of the canal basin at Gravesend for some twenty years, being removed after the demise of the owner, believed to be a Frenchman. It was towed around to Chalk Wharf, Queenborough, to be broken up in 2009. (A. L.)

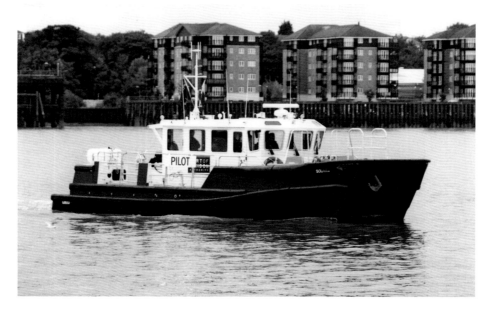

The Port of London (PLA) river and estuary pilots board and land from a launch based at Royal Terrace Pier. Their latest boat is the *Southwark*, a 13.5-metre twin-hulled aluminium craft built at Alnwick, Northumberland. Twin 200 hp diesels give her a speed of up to 20 knots. *Southwark* replaced the 16.4-metre *Patrol* of 1982, originally operated by Trinity House at Harwich and transferred to the PLA in 1988. (A. L.)

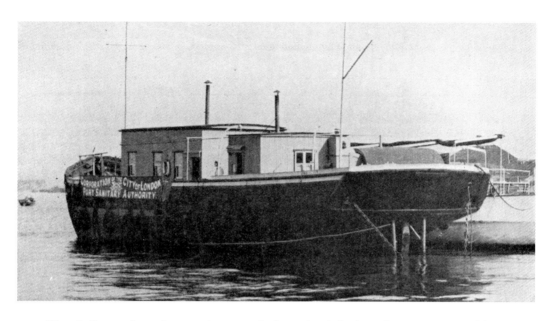

Historically, any incoming vessel suspected of carrying infectious diseases was visited by a doctor based on the *Hygeia*, the Corporation of the City of London Port Sanitary Authority's vessel moored at Gravesend. Various vessels carried this name. One was converted from the ex-William Watkins tug *Robert Bruce* in 1892. This ship was eventually replaced by the ex-collier *Elizabeth Blaxland*. A further replacement arrived in 1922 and served until November 1935, when this converted steel ex-Admiralty lighter of 1918 was moored off Denton to replace her. Any infectious cases brought ashore were usually transferred to the local isolation hospital.

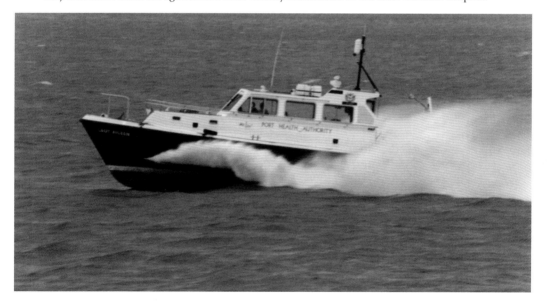

The Port Health Authority today is still administered by the Corporation of London but it currently has a wider brief, as fewer vessels arrive with crews having serious medical conditions. Shoreside food establishments are nowadays inspected over an area including the tidal Thames and Sheerness. In order to cover the distances involved, fast launches like the *Lady Aileen* are employed. (A. L.)

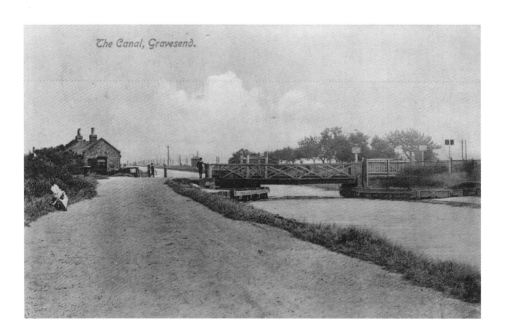

The Canal, Gravesend.

Opened in 1824, the Thames and Medway canal ran for 7 miles between Gravesend and Strood, allowing London shipping bound for the Medway towns to avoid the often choppy waters of Sea Reach and a voyage of up to 50 miles. It was not a commercial success, however, and by 1844 it had closed, the 2-mile tunnel between Higham and Strood being a bonus for the railway constructors. The Gravesend section of the canal remained open until much later, as shown here, but the lack of traffic indicates its disused state. (Thornton Bros, Balmoral Series)

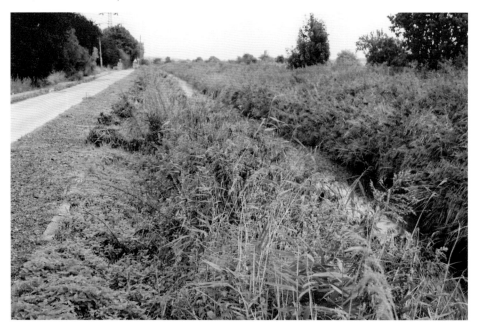

The same section today, south of the Metropolitan Police College, appears little more than a ditch, so much vegetation having invaded the waterway. (A. L.)

A view from Cliffe Fort up Gravesend Reach towards Tilbury power station. The derelict pier indicates how change is inevitable along the riverside, for nothing survives unless continuously maintained. Higham Bight provides a backwater for depositing unwanted maritime objects, including the bases of the Nore Fort towers at left middle ground. (A. L.)

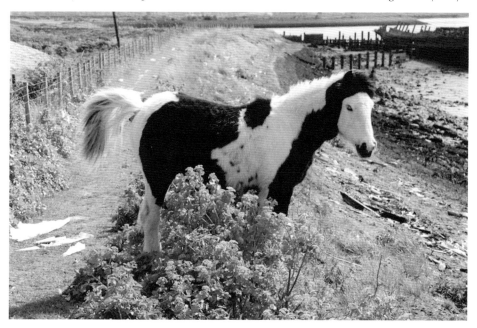

A horse investigates the same stretch of riverbank just along from the abandoned wreck of the auxiliary schooner *Hans Egede*, beached here around 1962 after suffering a fire. Alpha Cement works was situated here in the past, still remembered in nearby Alpha Jetty, which nowadays handles explosives and sea-dredged aggregates for Brett's, the *Britannia Beaver* being a frequent caller. (A. L.)

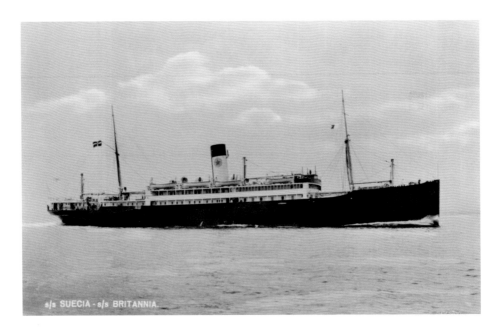

A miscellany of Scandinavian ships demonstrates how designs have changed over the past century. Swedish Lloyd's 4,600-ton steam turbine passenger ships *Britannia* and *Suecia* maintained a regular service from Tilbury to Gothenburg from 1929 up until 1966, the only break being for the war years. These Swan Hunter-built ships proved more successful than their larger replacements, *Saga* and *Patricia* of the 1950s. (Swedish Lloyd)

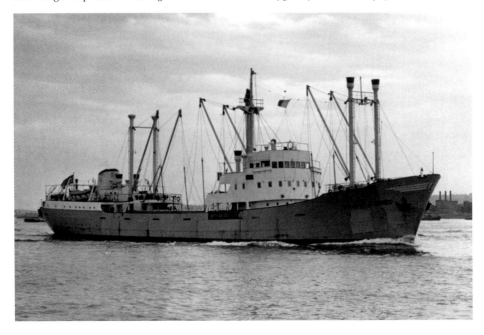

The *Baltic Comet* and her sister *Baltic Clipper* were British short sea traders operated by the United Baltic Corporation, mainly to Poland in conjunction with Polish Ocean Lines. Constructed in 1954, they had a modern appearance but *Baltic Comet* had a short life on the Thames, being sold to Pakistan in 1966. (P. Ransome-Wallis)

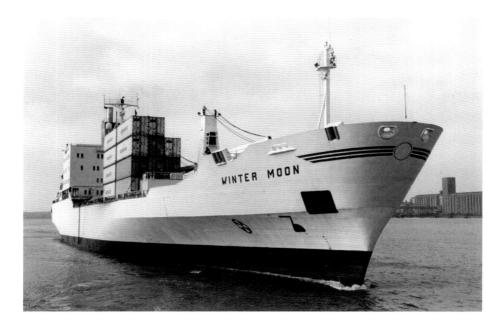

Winter Moon was one of a group of Swedish vessels constructed in 1979 for Sven Salen. Cranes had by that date become the standard for handling cargo in ports with no shore side facilities. Employed with her sisters in the fruit trade from the Caribbean, she is seen here after leaving Tilbury Dock in the 1990s. Evident also are the containers that were increasingly being adopted by banana importers. This 15,000-ton vessel was sold in 1999 to the Del Monte Fruit Produce Company, becoming *Alcazar Carrier*. (A. L.)

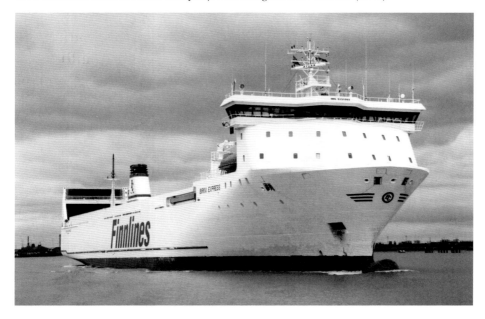

Birka Express, a Finnish forest products carrier built in 1997, shown chartered to Finnlines, has no cargo handling equipment, all cargo being driven aboard over a large ramp at her stern. The placement of the bridge right forward and the engine as far aft as possible makes for the maximum cargo capacity. (A. L.)

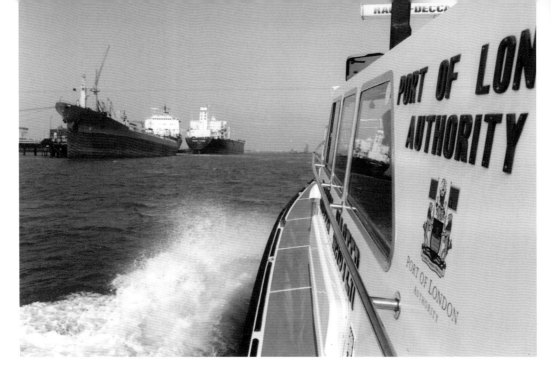

The PLA Harbour master's 44-foot launch *Gunfleet* approaches Coryton oil refinery at 20 knots to escort a large tanker to their No. 4 berth. Sea Reach has for a long time been the site of oil installations, most recently the refineries at Shell Haven and Coryton on the Essex side. The latter name originated in 1919, from the diversification of William Cory into oil storage on the site of an explosives factory. (A. L.)

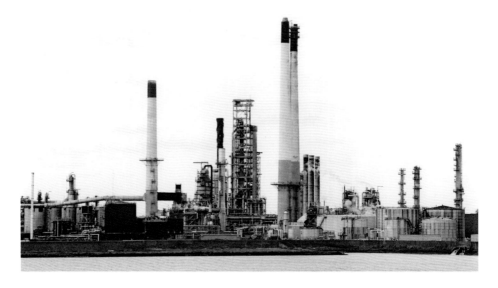

Shell Haven refinery closed around 1995 and was subsequently demolished to make way for the new Thames Gateway container port. Coryton, seen here in 2010, was owned by the Vacuum Oil Company in 1950, subsequently Mobil, who built a new refinery there in 1953, in parallel with that built by BP on the Isle of Grain. BP eventually took over Coryton in 2000 but sold it to the Swiss firm of Petroplus in 2007. (A. L.)

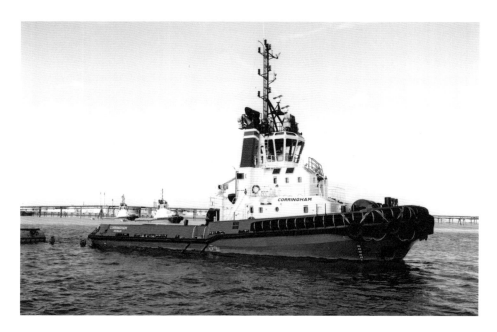

BP also owned one of the most short-lived tug fleets on the Thames. Preferring their own vessels for handling the oil tankers at Coryton, they ordered these three tugs from Damen in the Netherlands in 2004: the *Castle Point*, *Corringham* and *Stanford*. Delivered in 2005, they had full fire-fighting capability and a bollard pull of 66 tons, double that of the *Shorne*, illustrated earlier. They were sold following the failure of Petroplus in 2012, two going to Svitzers. (A. L.)

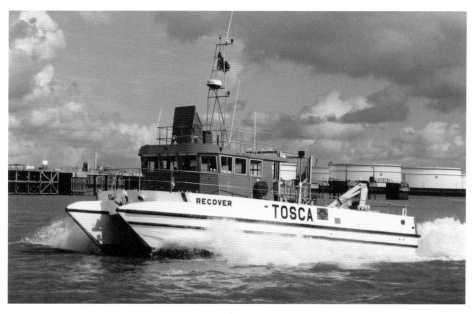

While the Thames has been fortunate with respect to accidents involving oil tankers, the PLA has for many years organised a system of rapid response in case any spill should occur. The vessel *Recover*, here also seen off Coryton, forms part of TOSCA, the Thames Oil Spill Clearance Association. (A. L.)

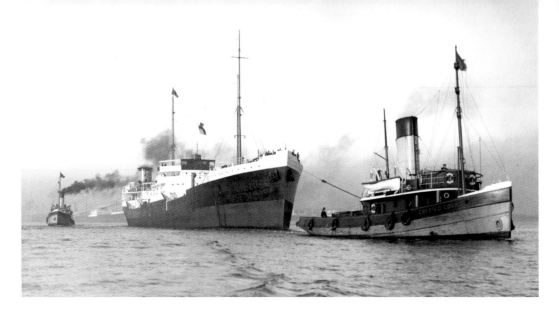

A view of the Shell tanker *Mactra* leaving a refinery in Sea Reach prior to the last war. Two Gamecock tugs, *Crested Cock* on the bow, are here manoeuvring the 9,100-ton tanker. Each would have had a bollard pull of about 10 tons, which demonstrates the advances made with *Corringham* on the previous page. *Mactra* remained in service until 1959. (H. Y. Scott, Gravesend)

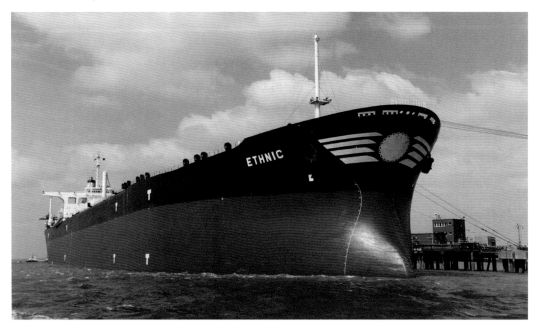

Crude oil was initially brought to both the new refineries at the Isle Grain and Coryton in so-called 'supertankers', and afterwards in the rather unattractively termed 'very large crude carriers' or VLCCs. *Ethnic*, seen at Coryton in 1998, was a typical steam turbine VLCC, built in 1975. She had a gross tonnage of 126,000 and a deadweight, or cargo capacity, of 274,000 tons when fully loaded. Resplendent here in new paintwork, she was broken up in India in 2000. (A. L.)

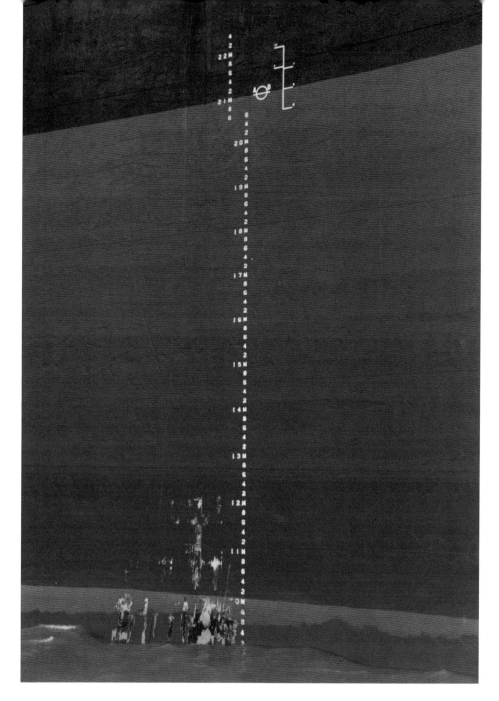

The Plimsoll line and draught marks of the *Ethnic* show that, fully laden, she would draw 21 metres (70 feet) of water. As the approach channel through the Black Deep in the Thames Estuary does not have that depth of water, such vessels were initially lightened to a draught of about 13 metres in European ports. Since refining on the Thames has now ceased with the demise of Petroplus, it is very unlikely that crude oil tankers of this size will be seen in the Thames again. They were instead replaced by very large container ships when the Thames Gateway Terminal opened in the autumn of 2013, the approaches having been dredged especially to accommodate their deep draught. (A. L.)

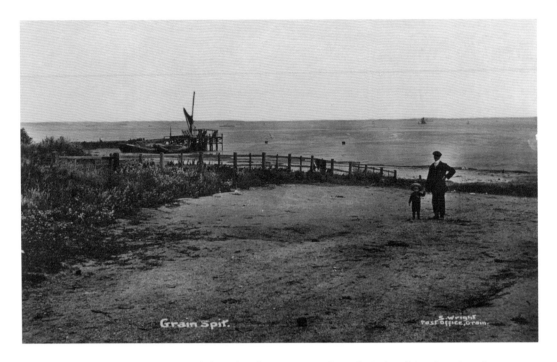

The easternmost extremity of the Isle of Grain was relatively isolated in Victorian times, the railway only running as far as Port Victoria. The salt marshes in the north were equally desolate and still lead to thoughts of *Great Expectations*. This could almost be Pip and Joe Gargery here. (S. Wright, Post Office, Grain)

Approximately the same view today shows increased sea defences and a few partly submerged remnants of the pier. While industry looms behind in the shape of the massive Grain power station and National Grid gas storage facilities, there is still the impression of an equally desolate seascape on this cold early summer's day. (A. L.)

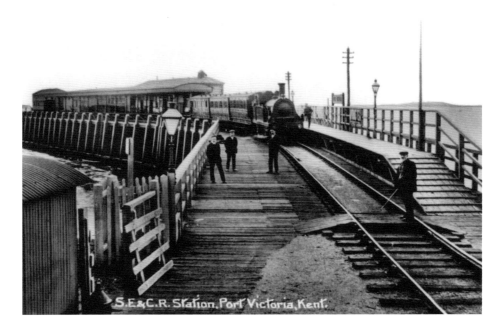

The South Eastern Railway (SER) completed the Hundred of Hoo line through to the newly created Port Victoria in 1882; a 400-foot pier was constructed there with the idea of starting a ferry service to Europe. Instead, it was the competition, in the form of the London, Chatham & Dover Railway, that succeeded in initiating a service from Queenborough to Flushing, the SER only supplying a connecting service across the Medway. Queen Victoria, however, found it a quiet departure point for travels in the royal yacht. This picture dates from around 1930.

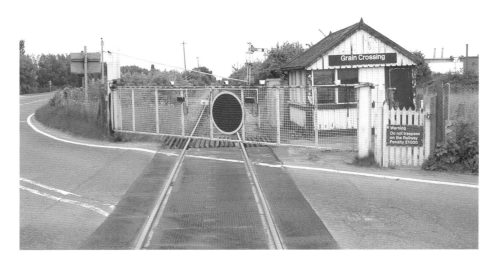

Port Victoria was absorbed long ago in the earlier BP oil refinery but the Hundred of Hoo railway line still survives to connect the Thamesport container terminal and the LNG facility with the main line at Shorne. The trackside equipment and level crossing gates seem to belong to an earlier age, suggesting use is at a minimum. (A. L.)

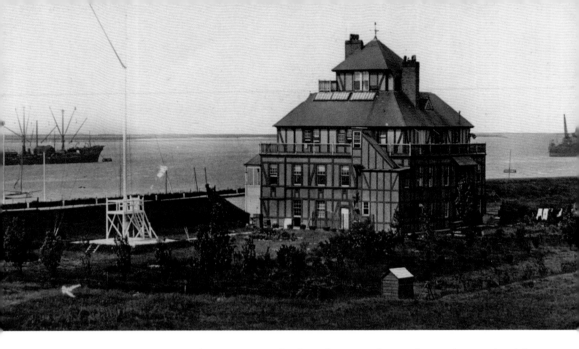

One organisation attracted to Port Victoria by the railway was the Royal Corinthian Yacht Club, which previously had its clubhouse at Erith. Pollution and congestion of the river was making sailing difficult and when the SER offered to build this clubhouse in 1897 they gratefully accepted. The club remained there until 1919, when they relocated to Burnham on Crouch. War brought many changes, the pier lasting until 1941 and the ex-clubhouse until 1946. (S. Wright, Post Office, Grain)

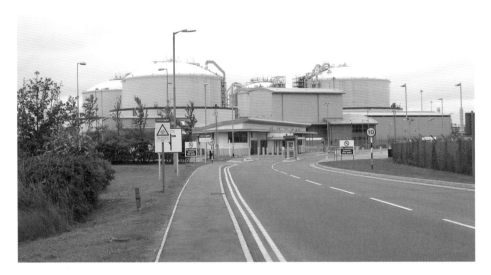

Nowadays the area is occupied by Thamesport's container berths, Foster-Yeoman Aggregates and the two liquefied natural gas (LNG) jetties, which can accept the largest QMax vessels. The major storage facility shown above, the largest in Europe, is operated by the National Grid. LNG is stored at -161°C in these huge cryogenic tanks, which have the capacity to supply 20 per cent of the UK demand for household gas. (A. L.)

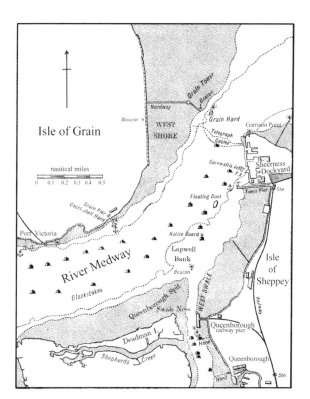

The Isle of Grain and ports of Sheerness and Queenborough as they appeared around 1933. At Sheerness the positions of the old Cornwallis Jetty, town pier and floating dock are all marked, as well as the railway pier at Queenborough used initially by the Flushing steamers and later by the minesweepers of HMS *Wildfire*. (After Imray, Laurie, Norie and Wilson)

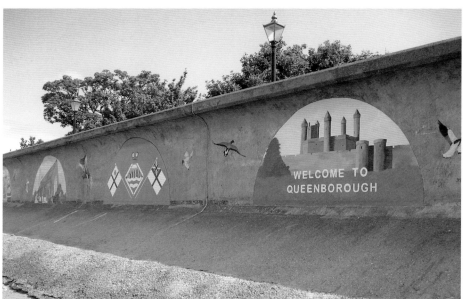

Those who arrive at Queenborough by water first encounter this sea defence wall, which appropriately bears a welcome and various historical murals. The nearest depicts the castle, a luxurious stronghold built by King Edward III in 1362–68, which defended the town against French raiders in 1450. It was demolished just a few years before the Dutch raid on the Medway in 1667. (A. L.)

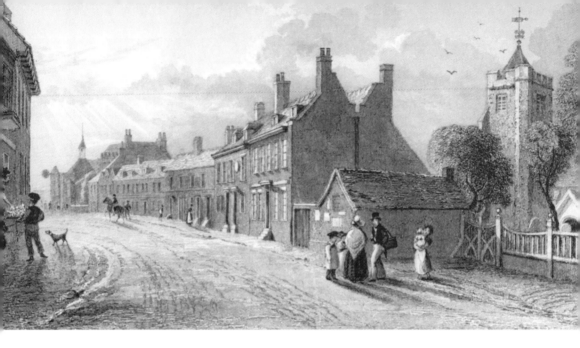

This engraving shows Queenborough High Street in 1830. The town was named in honour of Edward III's wife, the popular Philippa of Hainault. Later a nest of pirates and hotbed of unrest, it was captured by the Dutch in 1667, who hoisted their flag on the town hall. Apparently it was never officially handed back to Great Britain until a ceremony was held in the town in 1967, 300 years after the Dutch left. (T. M. Baynes, H. Adlard, Geo. Virtue)

Apart from the inevitable cars, the High Street appears relatively unchanged today, with the Guildhall in the distance and Church House at right, with its earlier connection with Emma Hamilton and Lord Nelson. Picturesque Holy Trinity church, dating originally from 1363, is omitted here. (A. L.)

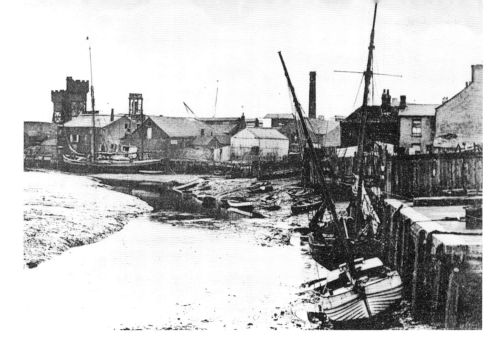

Queenborough has a long history, including periods of alternating prosperity and decline. This view of the creek looking seaward in Edwardian times shows in the background Stevens' Sheppy Glue and Chemical works of 1880, with its castellated tower at left and chimney at right, the emanations from which could sometimes be detected as far away as Kingsferry bridge.

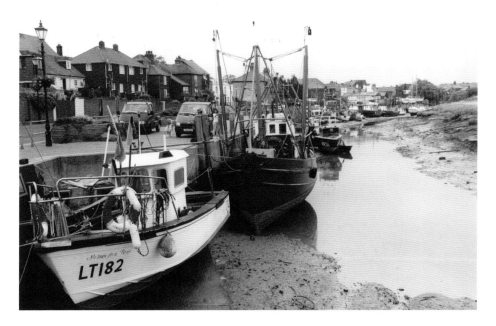

Several fishing boats line the South Street quays in this view from the opposite direction in 1996. Many and varied leisure craft nowadays also find berths in the creek, which dries at low water. Once a year a myriad of small vessels arrive for the ceremony of beating the bounds of the Medway. (A. L.)

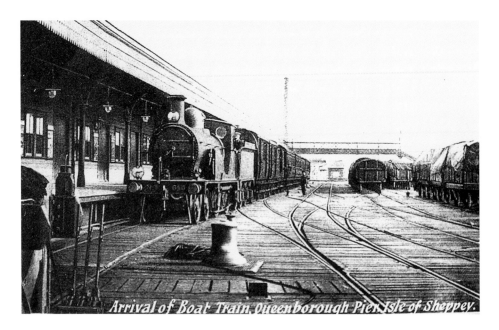

Arrival of Boat Train, Queenborough Pier, Isle of Sheppey.

Having bridged the Swale at Kingsferry, Queenborough railway pier was completed by the London, Chatham & Dover Railway in May 1876 and was used by the Dutch Zeeland Steamship Company ferries to Flushing until the First World War, when the service was transferred to Folkestone due to the deeper draught of the new turbine steamers. A boat train is here seen arriving on the pier. (H. C. Casserley)

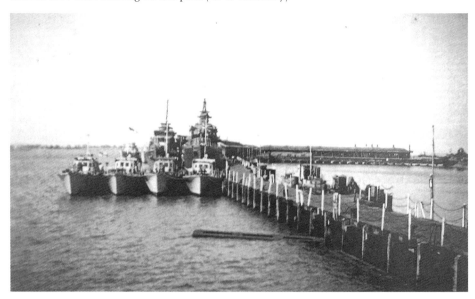

During the Second World War, the pier was lengthened for the use of the coastal minesweepers of HMS *Wildfire* that had relocated from Sheerness dockyard. Initially large numbers of converted trawlers berthed here, to be replaced later by specially constructed MMS and BYMS sweepers. This picture shows at rear the depot ships HMS *Garth*, outer, and HMS *Eskimo*, inner, which remained until the last of the minesweepers left in 1947. (Queenborough Guildhall Museum)

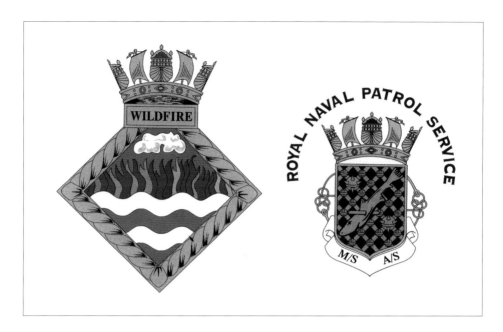

The badge of *Wildfire* III, based at Queenborough, together with that of the service, which arose out of the Auxiliary Patrol of the First World War and which had performed so valiantly as part of the Dover Patrol. The later *Wildfire* BYMS sweepers worked both from Dover and Queenborough to clear French and Belgian waters of mines after the ports were liberated in 1944–5. (Queenborough Guildhall Museum)

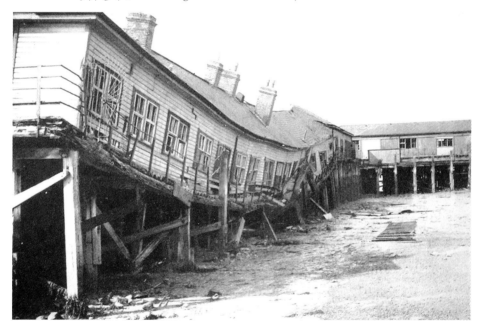

Queenborough pier, which had been extended southward almost as far as the Aesica boundary today, had deteriorated considerably by the late 1940s. The severe storm of January 1953 wreaked havoc at Sheerness and caused part of the valiant pier to collapse. No longer required by the Navy, it was demolished in 1956.

ALFRED JOHNSON & SON
LIMITED

An early chemical industry existed at Queenborough involving the processing of copperas (ferrous sulphate), which occurred in the cliffs locally to produce sulphur, sulphuric acid and related fertilisers. At the beginning of the twentieth century other industries arrived, including the pottery of Alfred Johnson & Son, which manufactured sanitary ware. This classical composition is taken from the title page of a history of the company.

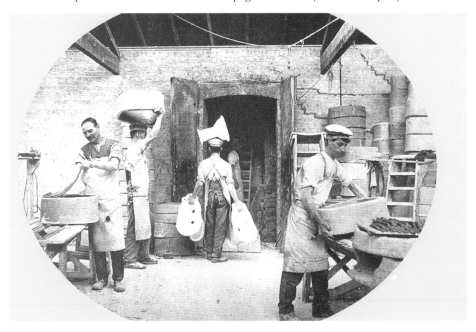

Workers at Alfred Johnson's pottery works are seen removing what appear to be bidets from their moulds and carrying them to the stores. The methods employed show great efficiency but might not meet today's health and safety standards. (Alfred Johnson & Son)

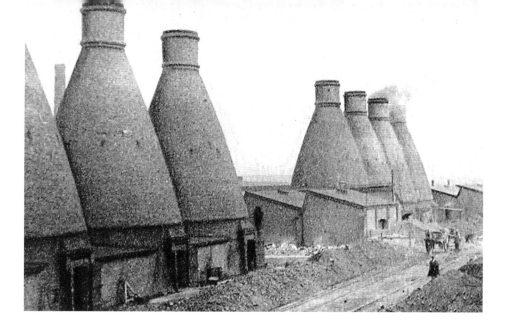

Reminiscent of Johnson's Stoke-on-Trent origins, these bottle kilns remained a prominent feature of the Rushenden Road landscape until they were replaced by electric ovens in the 1950s. Later taken over by Doultons, the site was closed in the 1980s and now forms part of the Klondyke redevelopment area. The Canning Town Glassworks nearby manufactured countless numbers of beer bottles. Large housing developments for the factory workers were built to the east of the main railway line and also to the south, in the neighbourhood of Sheet Glass Limited (later Pilkingtons). (Alfred Johnson & Son)

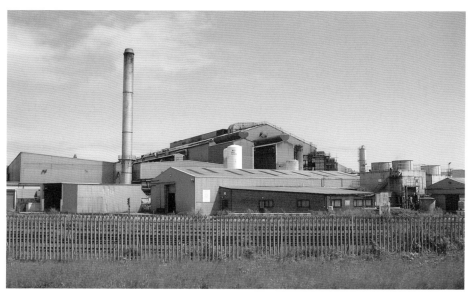

Lying close to the entrance to Blue Town pier, Sheerness steelworks was built on Army playing fields by Canadian firm Costeel in 1972 to produce coils and concrete reinforcing rods from scrap. It remained profitable until around 1980 but in spite of further investment it was sold to ASW Holdings in 1998 and then to Thames Steel in 2002. Further attempts to improve its viability failed, and the works finally closed in January 2012. (A. L.)

Another firm to arrive at Queenborough in the early twentieth century was Settle, Speakman & Sons, who built the coal washer wharf above in 1908, on the spit of land that extends outward to Long Point (see also map below). Coal arriving from north-east England was cleaned, graded and sold in the local towns as Best Selected for 25s (£1.25); Best House 24s (£1.20); and Best Kitchen 23s (£1.15) cash per ton. (Settle, Speakman & Sons)

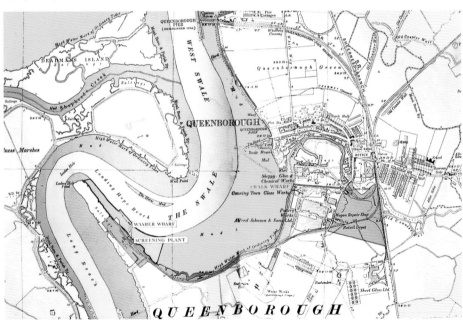

Settle Speakman extended their interests into other areas, including the development of a railway network to supply other factories. The layout of most of the Queenborough industrial premises is shown, with Settle Speakman's activities, including the Chalk Wharf, highlighted. (Settle, Speakman & Sons)

Another undertaking, which ultimately gained considerable fame, was the shipbreaking firm of engineer Ernest Cox (1883–1959) and his financial partner Tommy Danks, who he later bought out. Cox took over the disused Queenborough Pier, previously used by the Zeeland Steamship Company, in 1922 and demolished the surplus 22,500-ton battleships HMS *Orion* and HMS *Erin*, the *Orion* being in the foreground. They were 525 feet in length and had ten 13.5-inch guns. Cox afterwards purchased an ex-German floating dock, which he later moved to Scapa Flow to assist the lifting of a large number of the scuttled vessels of the German High Seas Fleet during the 1930s. He became famous for his success in raising these ships, which did not, however, go to Queenborough for scrapping, the distance being too great. His yard on the Medway was sold to Metal Industries in 1949. (Cox & Danks)

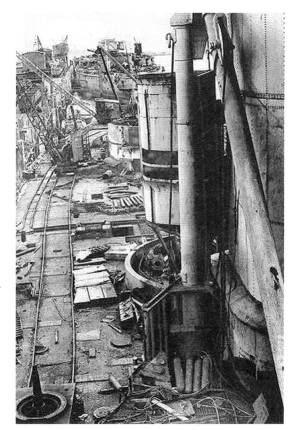

Shipbreaking continued, until relatively recently, close to the now-disused Coal Washer Wharf; this illustration shows the Central Electricity Generating Board collier *James Rowan*, built in 1955, being broken up there in 1985. The cranes are believed to date from 1953. (Ted Ingham)

33

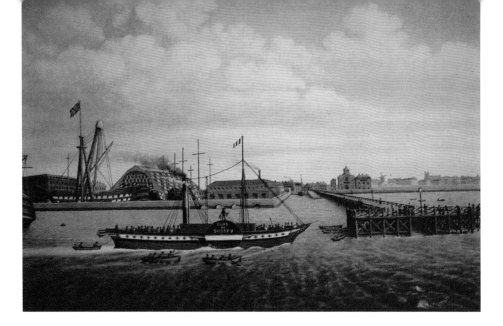

The first shoreside feature encountered at Sheerness was Blue Town pier, first opened in September 1835. It was of great importance for the landing of passengers, freight and mails by steamer until the Swale was bridged and the railway arrived in 1860. Fifteen years later, the Zeeland SS Company commenced their regular sailings to Flushing but soon moved to Queenborough. It had few facilities but offered a good view of the naval dockyard. Unfortunately, it was destroyed in the storm of November 1897. (Harold Batzer, 1836)

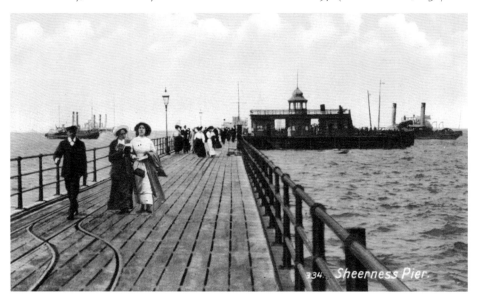

A replacement built on iron columns was opened in 1899, with a shelter at its head which housed a tea room. It continued to welcome steamers from the Thames and Medway until war came, when it was requisitioned by the Admiralty. Declared unsafe in 1955, it was closed. Attempts to refurbish it then failed and the closure of the dockyard in 1960 led to further uncertainty. In 1965 it was purchased by Medway Ports, the dockyard's new owners, who demolished it in 1971 to make way for more commercial berths. (J. Welch & Sons, Portsmouth)

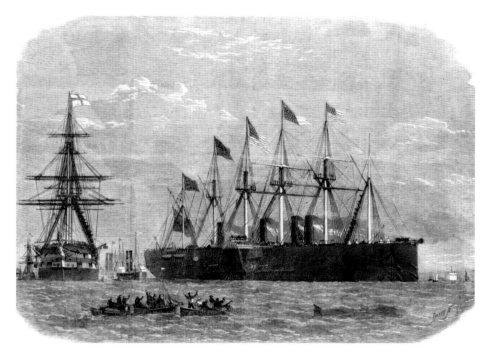

Sheerness pier allowed the public to also view the many interesting ships that passed by. One major attraction was Brunel's impressive SS *Great Eastern*, which came to Sheerness to load cable for the transatlantic telegraph in July 1866. Numerous steamer excursions were also run from the Thames to see the great ship, which returned in 1869 to collect cable for the French link with America. (*Illustrated London News*)

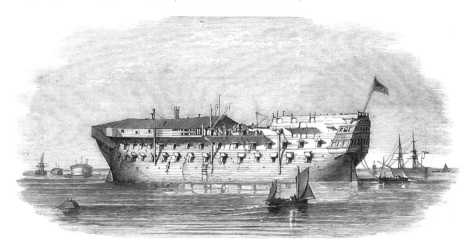

Wooden hulks of old men-of-war were a common sight at Sheerness for many years, since they had provided dockyard workers with accommodation from the late seventeenth century until suitable dwellings had been built ashore. Similar 'receiving ships' were the destination of pressed men collected from ports up and down the country. The *Devonshire*, above, an ex-third rate of 74 guns built in 1812, was, with the *Benbow*, accommodating 1,140 prisoners and their families from the Crimean War on this occasion in 1854. (*Illustrated London News*)

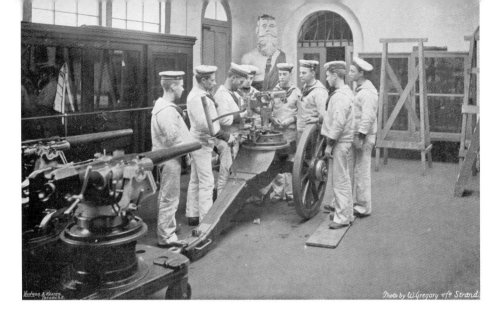

A Royal Naval gunnery school was established in April 1892 at Sheerness Dockyard and plans were made for its enlargement, but lack of space meant that it was moved to Chatham in June 1908. In this view of 1896 a large ship's figurehead overlooks a Maxim gun class. One notable event in the gunnery school's brief history was a cricket match, arranged by Lieutenant H. E. Grace, between a *Wildfire* team and a London County team captained by his father, W. G. Grace. The results were *Wildfire* 113, London County 164, of which Dr Grace scored 111. (W. Gregory, *The Navy and Army Illustrated*)

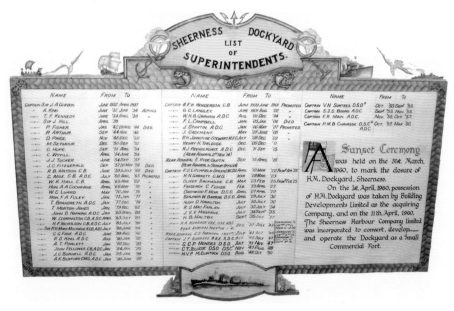

The importance of Sheerness dockyard is demonstrated in this list of superintendents from 1832 to its closure in 1960. Having its origin in the time of Charles II, the loss of the dockyard had a profound effect on the local community. The Nore Command, established around 1752, which also achieved great importance in wartime and witnessed the famous naval mutiny of 1797, was terminated on 31 March 1961. (Blue Town Heritage Centre, Sheerness)

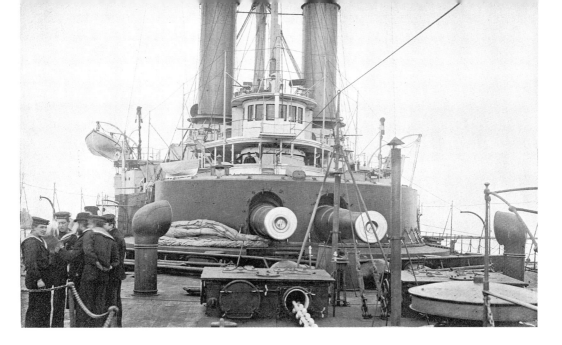

After the Dutch raid on the River Medway in 1667, a guard ship was almost always anchored off Sheerness. In the last years of the nineteenth century the 10,720-ton battleship HMS *Sans Pareil*, sister of the ill-fated *Victoria*, fulfilled that role. She was constructed by Thames Ironworks in 1887 and broken up in 1907. Prominent here in this foredeck view of 1896 are her two 16.25-inch guns. (W. Gregory, *The Navy and Army Illustrated*)

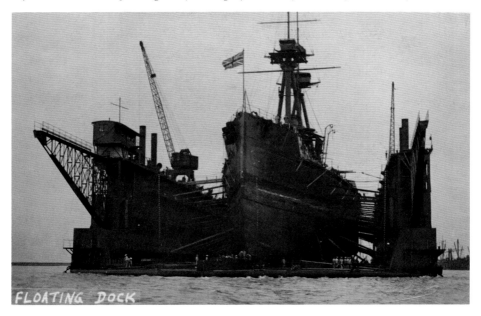

In 1902 HMS *Sans Pareil* was used to test a large floating dock, which was then towed out to Bermuda. Ten years later Sheerness obtained an equally impressive dock, which was moored in Saltpan Reach. It was capable of lifting the largest warships of the time and is shown here with the battleship HMS *St Vincent* of 19,250 tons, docked for the initial trials. Various other floating docks were moored at Sheerness up to the closure of the dockyard in 1960.

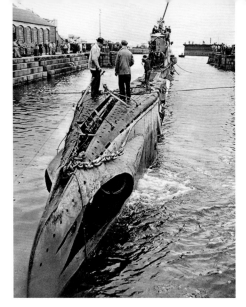
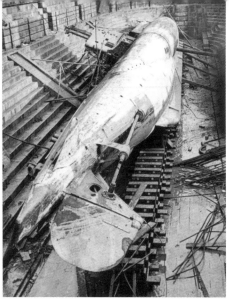

The Medway has experienced disaster, a particularly tragic example being the explosions of the battleship HMS *Bulwark* and minelayer HMS *Princess Irene* in the First World War. A later victim was the submarine HMS *Truculent*, seen above left, sunk by collision seaward of the Nore on 12 January 1950 with the loss of sixty-four crew and Chatham Dockyard workers; it is seen here after being raised and brought to Sheerness (the Sphere). Another submarine, S-class HMS *Sirdar* of 1943, appears at right capsized in No. 1 dry dock at Sheerness after the yard was flooded by the storm of 31 January 1953. While the *Truculent* was broken up, *Sirdar* went on to serve for another thirteen years.

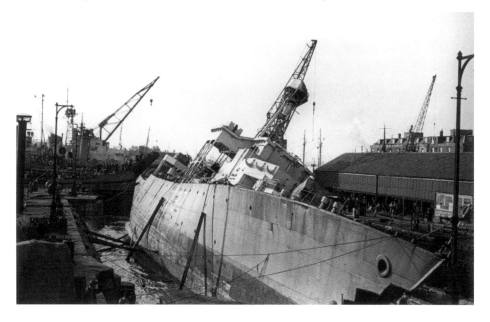

Another victim of the same 1953 storm was the frigate HMS *Berkeley Castle*, lying in No. 2 dock next to the *Sirdar*; the vessel eventually fell over on her side. Such was the damage further incurred in righting her that she was never re-commissioned and was instead sold for scrap three years later.

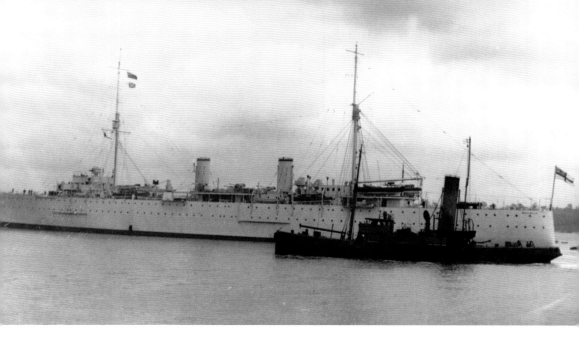

This typical Medway scene from the 1930s shows the naval depot ship HMS *Woolwich* escorted by the Sheerness paddle tug *Firm*. The *Firm* was built at Chatham Dockyard in 1911 and was for a long time companion to the twin-funnelled *Cracker* of 1900. Both had an indicated hp of 1,250, equivalent to a bollard pull of about 10 tons. *Cracker* was scrapped at Grays in 1956 and *Firm* at Antwerp in 1960. (Medway Studios)

Progress in ship-berthing tugs is evident in this October 1998 view of Howard Smith's new *Lady Emma H*. Fully rotating twin 'Z' drive propellers allowed movement in any direction at close to full power. In the background lies Grain power station, opened in 1979, its huge 244-metre (800-foot) chimney visible for many miles out to sea. A gas-burning 1,275 MW electricity generating plant has now replaced the original station, which closed at the end of 2012. (A. L.)

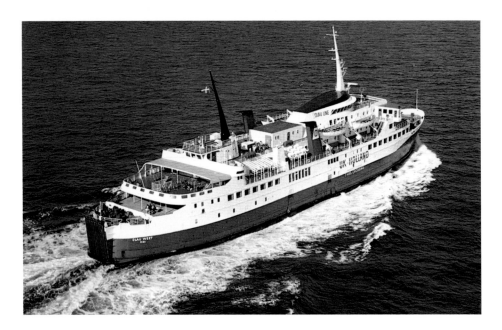

After the Zeeland Steamship Company left Queenborough for Folkestone in 1914, there was no regular passenger ferry service to the Continent until Olau Line began their service to Flushing from Sheerness in November 1974. In service from January 1975, the 3,000 gross ton *Olau West* could carry up to 722 passengers and 184 cars on the 7-hour crossing. She was sold to Corsica Ferries in November 1977. (Olau Line)

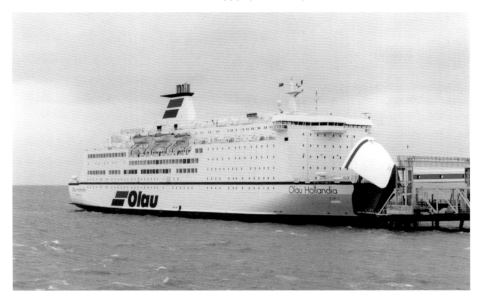

The increasing popularity of the route meant that Olau ordered the new ferries *Olau Hollandia* and *Olau Britannia* for delivery in 1981. Capable of carrying 550 cars and around 1,600 passengers, these ships introduced the idea of cruise-ship comfort to regular cross-Channel ferries. Demand was such that by the mid-1980s even larger vessels were needed and two 33,000-ton ships were ordered for 1989. They were named as their predecessors; the *Olau Hollandia* (II) is seen here moored to the newly constructed pier at Sheerness. (John Gurton)

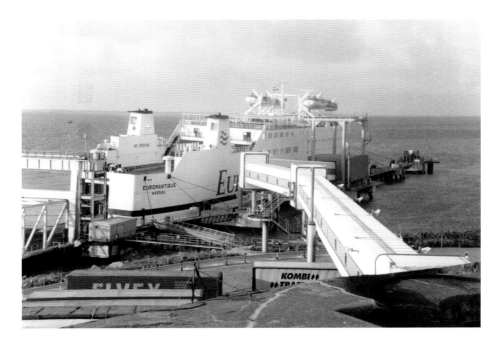

Unfortunately, Olau Line had overreached themselves and pride in the new ferries was replaced by failure in 1994, with the last sailing coming in May. The Port of Sheerness, faced with no service, set up the company Eurolink with the two chartered vessels *Euromagique* and *Euromantique*, the latter seen here in 1995, but this service did not succeed either, ending on 30 November 1996. Thus, sadly, the later Flushing ferry came to an end. (A. L.)

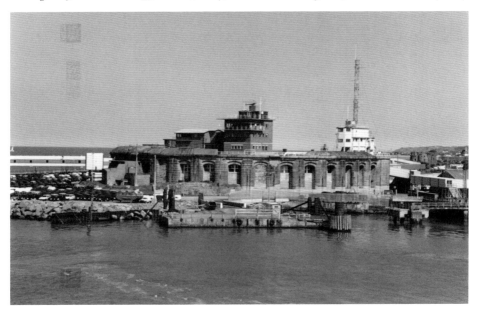

A general view of the Palmerstone-era fort at Garrison Point from where Medway Ports' VTS and Port Control officers monitor the river and its approaches. Part of the central accommodation dates from June 1981, when Trinity House provided the pilotage. At right is the old naval signal station, while directly in front is No. 11 berth, used mainly by tugs. (A. L.)

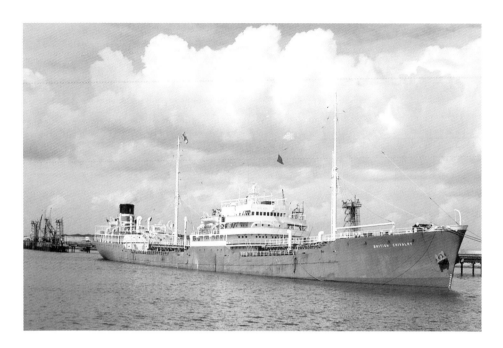

The intermediate tanker *British Chivalry* was typical of the many British Petroleum tankers that called at the Isle of Grain refinery, opened in 1952. This vessel was built in 1949 and is seen here in 1963; it served some of its life with the subsidiary BP Clyde, when it took the name *Clyde Chivalry*. It was eventually broken up in Spain in 1972. (J. Hopkins – World Ship Society)

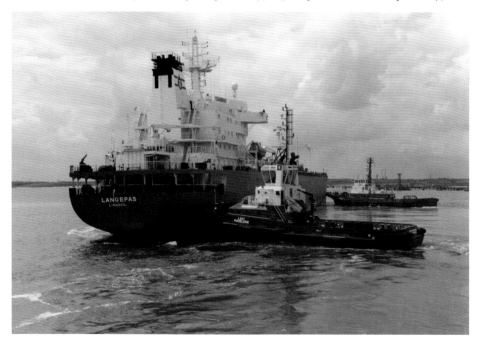

Only No. 1 berth of the refinery was retained after its closure for the storage of aviation fuel. This view shows the mooring of the new Cypriot-flagged tanker *Langepas* at No. 1 jetty by Howard Smith's tugs *Lady Madeleine* and *Lady Brenda* in June 1998. (A. L.)

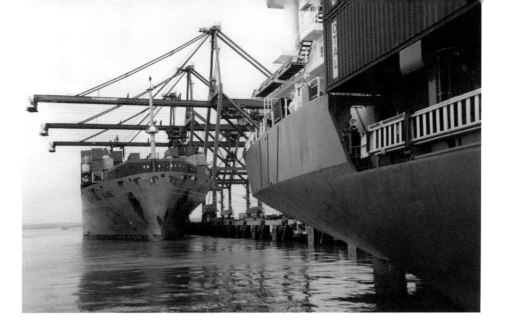

The majority of the refinery site was re-developed, part being taken by the Thamesport Container Terminal. Replacing the *British Chivalry* are the container ships M/V *Kaiama* (foreground) and *Neptune Jade* in this view of August 1996. Sharing of space in ships and other economic factors have caused routing changes such that nowadays mostly smaller feeder vessels berth at Thamesport. (A. L.)

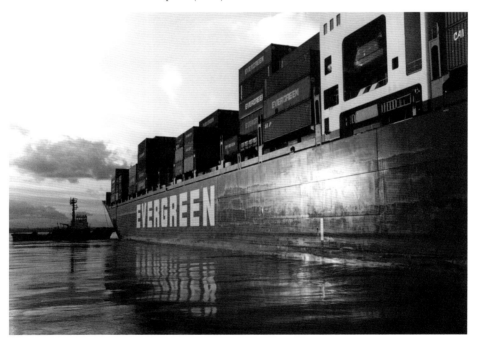

As the sun sets in October 1998, the 52,000-ton *Ever Dainty* arrives at Thamesport. Evergreen Marine Group of Taipei was among the Container Terminal's first customers, the *Ever Glowing* being their first ship alongside, in July 1991. They remained regular visitors until July 2013, when their China Europe Shuttle service transferred to Felixstowe. (A. L.)

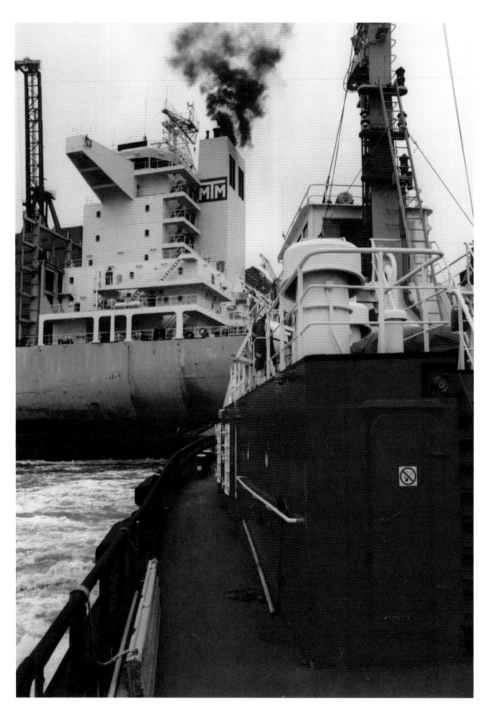

Numerous shipping companies have called at Thamesport over the twenty-three years since its opening. Another long-term visitor, Hapag Lloyd, also departed in 2013. United Arab Shipping Corporation ships are no longer seen; nor are those of Maersk, or the Linea Mexicana ships, including the 30,000-ton M/V *Yucatan* of Veracruz, here being hauled away from the wharf in 1996 with a dramatic display of power by Howard Smith's tug *Lady Morag*. (A. L.)

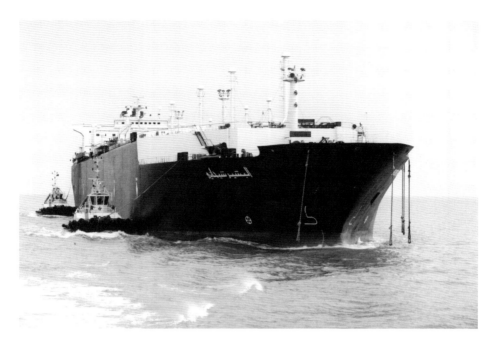

Since 2005 the eastern end of the old refinery site has been developed to receive cargoes of liquefied natural gas. Two new jetties allow tankers of more than 100,000 tons to discharge LNG from the Middle East. The Algerian-flagged steam turbine vessel *Bachir Chihani*, built in 1979, dwarfs her tugs as she enters the River Medway in 2008. (A. L.)

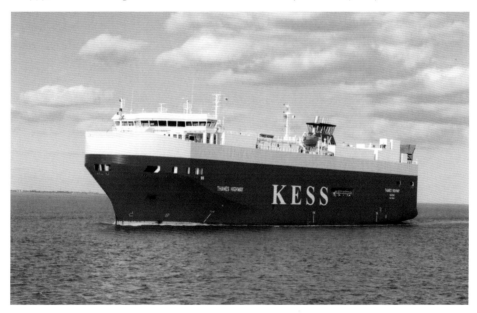

In the 1990s Sheerness became an important port for the import of motor vehicles and a large part of the Lappell Bank was reclaimed to extend the storage area. Companies calling include Wilh. Wilhelmsen, Wallenius, United European Car Carriers, Lineas Suardiaz and Kawasaki European Sea Highway Services (KESS), whose locally named *Thames Highway* of 2005 is seen passing Garrison Point in full sunlight shortly after completion. (A. L.)

Left: Fruit has historically also been a major contributor to the success of the Port of Sheerness. Four different vessels involved in the trade are illustrated. In the first, *Eriksson Crystal* leaves the Medway in calm weather in October 1994, a time before the containerisation of fruit. (A. L.)

Below: Lauritzen Reefers' *Arctic Swan* approaches Sheerness in April 1997. The traditional reefers of Cool Carriers and Seatrade were also frequent visitors but the transition to containerisation has led recently to more fruit arriving aboard container ships at other places. Consequently the elegant lines of the classical reefers are becoming less common in the Medway. (A. L.)

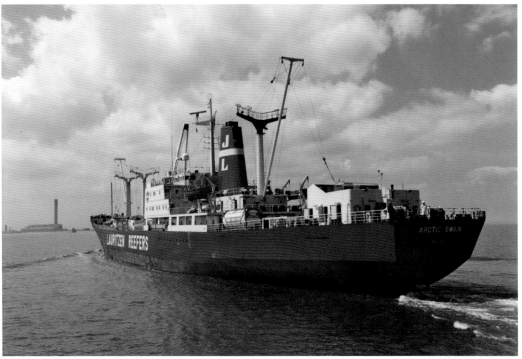

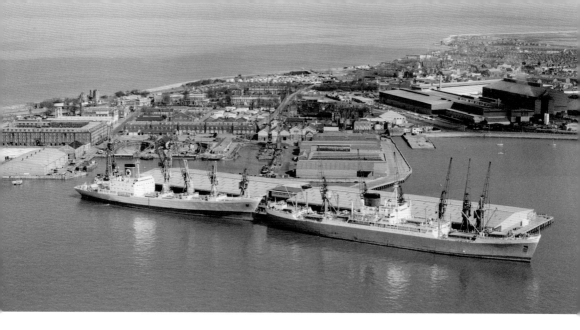

New berths Nos 2 and 3 were created seaward of the old dockyard during the 1970s. Two British cargo liners appear in this view from 1975. To the rear of Blue Star Line's fruit ship *Andalucia Star* (left), on berth No. 2, lie the Great Basin and the remains of the dry docks where HMS *Sirdar* and HMS *Berkeley Castle* were capsized in the 1953 storm. The refrigerated Port liner *Port Nicholson* is unloading meat on berth No. 3. The new Sheerness Steel plant occupies the right background.

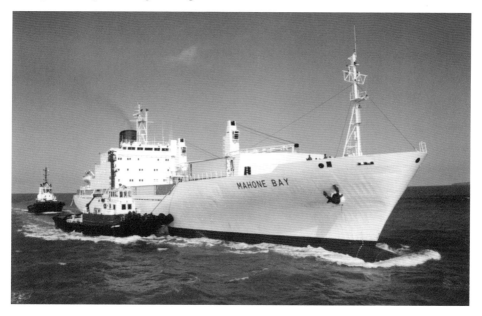

The final reefer illustrated is Seatrade's *Mahone Bay*, here being guided to her berth by Howard Smith's tugs *Lady Morag* and *Lady Madeleine* on a beautiful day in July 2000. Cargo-handling cranes are apparent on this more modern ship. Built for speed, these attractive vessels often enjoyed long service but also enjoyed a variety of names. They also remained of moderate proportions, unlike tankers, bulk carriers and container ships. (A. L.)

Ships longer than 50 metres must take a marine pilot to ensure safe navigation of the Thames Estuary and River Medway. Pilots are often strong characters, having to communicate with different ship masters, some with only a smattering of English, during the night or day in almost all weathers. On this occasion in 1994, Medway pilot Trevor Jewsbury guides Captain Gapski of the feeder container ship M/V *Girlin* inward bound for Thamesport. (A. L.)

Three other Medway pilots are seen aboard the launch taking them from Ramsgate to the boarding point for their ships, near the north-east spit of the Margate Sand. They are, from left, John Carlton, Andy Davison and Alan Milburn. John and Alan were both originally employed by Trinity House. Andy moved to Australia, while the others remained at Sheerness until their retirement. (A. L.)

Officers of the Vessel Traffic Services team (VTS) monitor the port area and approaches by radar and radio in order to avoid any difficult situations and navigational errors. Richard Beet was for most of his sea-going career employed by the London, Rochester Trading Co., later Crescent Shipping. (A. L.)

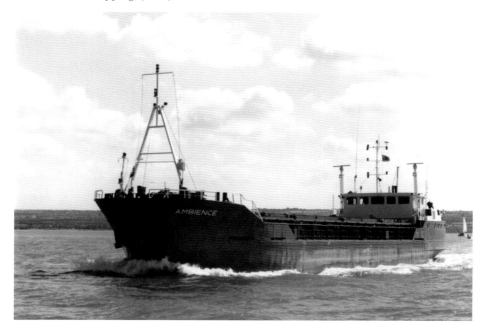

Richard was master of a number of Crescent's vessels, one of which was the M/V *Ambience*, the last ship to be built on the Thames, launched by Cubow at Woolwich in 1983. He was later master of the M/V *Thames*, running daily for Thames Water out to the Barrow Deep until 1998. When that service ended he joined Medway VTS, retiring in 2013. He enjoys private flying in his spare time. (B. Pawley, World Ship Society)

Royston Potter is another of the VTS team at Sheerness who also came from Crescent Shipping. On leaving school he joined the motor barge *Rock* as mate. He also moved to Thames Water, becoming master of the M/V *Hounslow* (above) after John White. He still maintains an interest in the sailing barge matches. (A. L.)

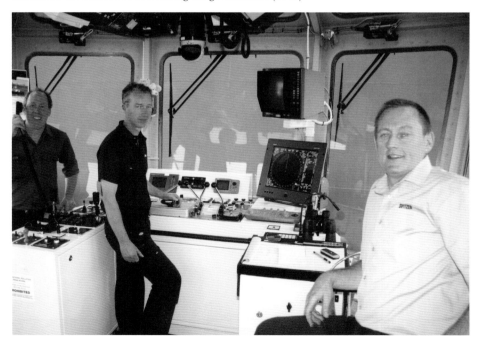

Also important to the safe mooring of ships are the tugs and their crews. Holding a car carrier alongside her berth in 2008 with the *Svitzer Victory* are, from left, Paul Ashby, engineer; Paul Jarvis, mate; and Paul Kite, master. (A. L.)

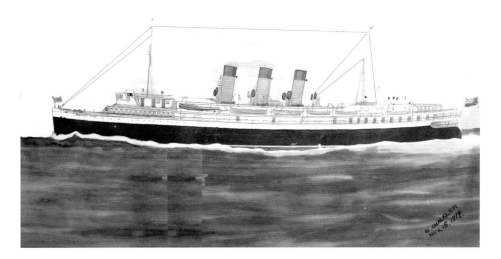

The Sheerness area has experienced its share of disasters aside from the weather. Worst in terms of loss of life was the explosion of the minelayer *Princess Irene*, which exploded in Saltpan Reach on 27 May 1915. This contemporary painting shows her as built, in Canadian Pacific Railway colours. Seventy-eight Sheerness Dockyard workers were killed in addition to the crew aboard the 5,900-ton minelayer, making around 270 in total. There was only one survivor. (G. Chalklen)

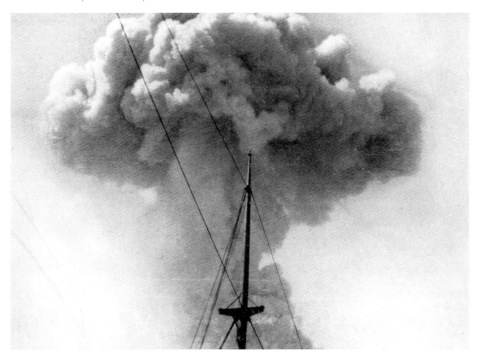

The explosion of the *Princess Irene* was likened to a volcanic eruption, producing the mushroom cloud shown in this picture. Debris rained down over a wide area, causing at least one fatality. The cause was never exactly identified but eventually attributed to unsafe procedures in arming the mines. (*The Illustrated War News*)

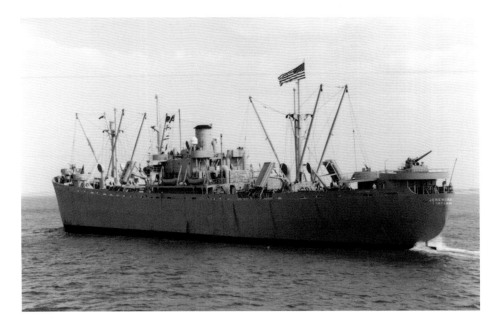

There were numerous enemy air attacks on Sheerness Dockyard during the Second World War, but it was the ship that came closest to devastating the harbour. On 20 August 1944 the US Liberty ship *Richard Montgomery*, loaded with a cargo of 6,000 tons of bombs and shells, anchored close to Sheerness Middle S and later went aground on a spring tide. All subsequent attempts to refloat her failed. Sister Liberty *Jeremiah O'Brien* is seen here leaving the Medway at the time of the 50th anniversary celebrations of D-Day. (Rod Chalmers)

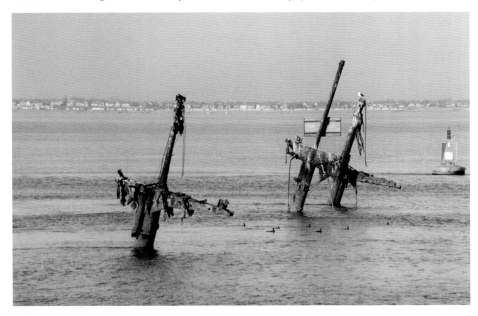

Early salvage efforts removed about half of the cargo of the SS *Richard Montgomery* but the remaining 3,000 tons still remain in and around the broken hull of the vessel. Surveys are regularly carried out by naval divers but no recent attempts have been made to recover it, the wisest course being to leave the wreck undisturbed. (A. L.)

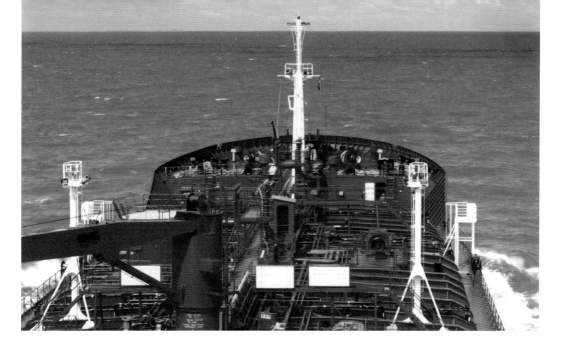

The Prince's Channel is the main approach to the Thames and Medway on the south side of the estuary. Running almost exactly east–west, it has been deepened in recent years to allow larger-sized vessels to reach their destinations at most states of the tide. In June 2009 the tanker *Weichselstern* (Vistula Star) heads along the Prince's Channel towards Grain No. 1 berth with 20,000 tons of aviation fuel. (A. L.)

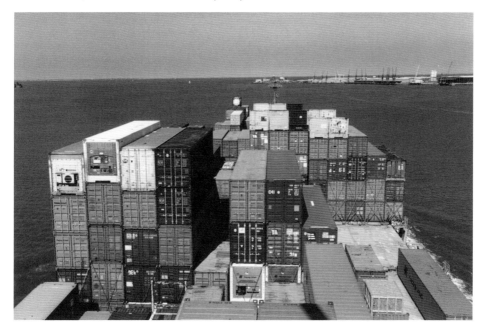

Outward bound from Thamesport, the containership *Hong Kong Express* heads towards Garrison Point in May 1998, taking the deep water route through the Black Deep to the Sunk pilot station and onwards to Bremerhaven. The ship has a length of 245 metres and a typical service speed of 20 knots. Hapag-Lloyd now has a much larger vessel of the same name. (A. L.)

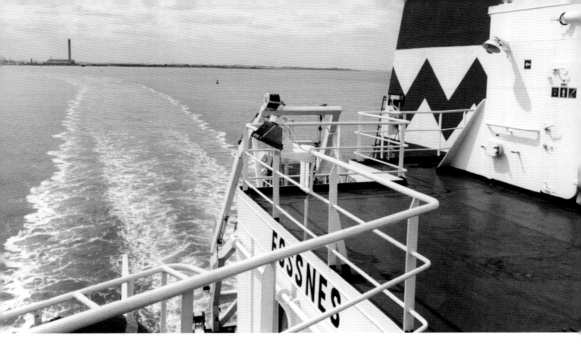

Jebsen's 10,000-ton bulk carrier *Fossnes* leaves the Medway and the landmark Grain Power Station behind as she heads for the East Oaze and the Prince's Channel. The ship has earlier 'canalled' out of Chatham Dock, leaving at high water with both lock gates open due to her size. Her large propeller caused severe vibration when passing over the shallow part of the channel at the Girdler. (A. L.)

Increasing cloud combines with the wake of the Sheerness pilot boat to create an ever changing kaleidoscope of visual effects on the water near the Medway buoy, which lies 5 miles seaward of Garrison Point. It marks the position where small vessels board or land their pilots. (A. L.)

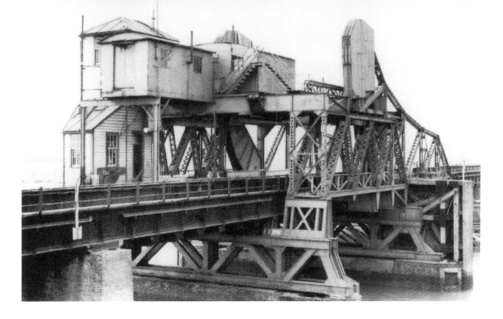

The Isle of Sheppey is separated from the rest of Kent by the Swale, a stretch of water only bridged in 1860 when a fixed railway and road link was built at the site of King's Ferry. It was replaced by this bascule bridge in 1914 in order to give ships access to the newly completed Ridham Dock. In spite of occasional closure due to damage, this second bridge enjoyed a long life, not being replaced until 1960.

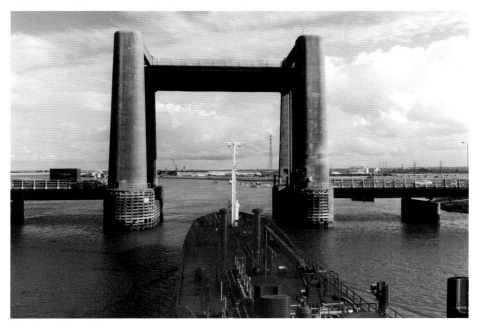

M/V *Sydstraum* is seen here passing through its replacement en route for Ridham. This bridge has a length of 650 feet, width of 50 feet and a lifting span weighing 465 tons. Constructed by John Howard & Co., it was opened by HRH the Duchess of Kent on 20 April 1960. Trains always take precedence. Ships' pilots must request the time of a bridge lift from an office in Sittingbourne and time their approach or departure accordingly. The construction of the new Sheppey Crossing has avoided the traffic delays caused by bridge lifts. (A. L.)

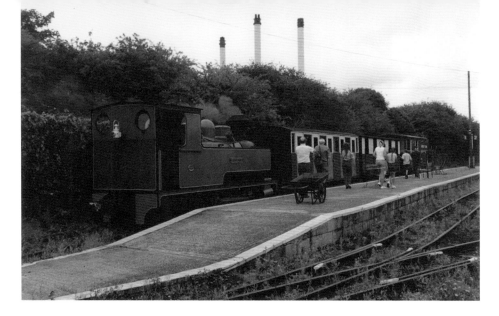

Edward Lloyd constructed a narrow gauge railway to connect his Sittingbourne paper mill with Ridham Dock, operating steam locomotives after 1905. Taken over by Bowaters in 1936, the line was given to a railway preservation group in 1969. The land was later sold and the railway partly dismantled. However, the Sittingbourne end was taken over by the Sittingbourne & Kemsley Light Railway, who have kept the line open as far as Kemsley Halt, where the ex-Bowater 0-6-2T engine *Superb* of 1922 is seen with a passenger service in 1997. (A. L.)

The most notable church on the island, Minster Abbey, is situated at the highest point on the north coast. Originally founded by Queen Sexburga in AD 664, it was in serious decline by AD 1130 and another church was built alongside it. The newer church was dismantled when Henry VIII dissolved the monasteries but the original nuns' church was saved as the only place of worship. At that time, the land was given to Sir Thomas Cheyne, Lord Warden of the Cinque Ports. (A. L.)

Eastchurch was famous as a cradle of aviation. Its early airfield and the one at Leysdown were used by Orville and Wilbur Wright, Charles Rolls, Horace Short and other aviation pioneers. Winston Churchill learnt to fly at Eastchurch when First Sea Lord, staying aboard the yacht *Enchantress* in Sheerness Dockyard while he did so. Eastchurch eventually became the main flying field, there being eighteen of these aircraft sheds by 1910.

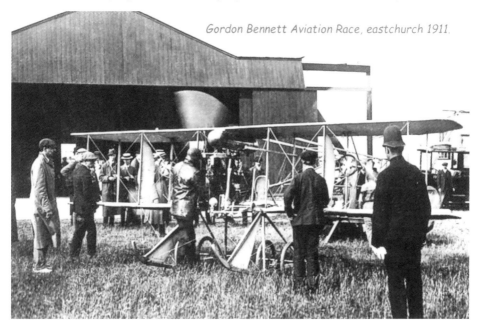

Gordon Bennett Aviation Race, eastchurch 1911.

In 1911 the famous Gordon Bennett Air Race was held at Eastchurch, the third after Rheims, France, and Long Island, USA. Pilots were required to fly twenty-five laps of a 3.76-mile course, the race being won by an American with Frenchmen second and third. A typical aircraft of the time is the Baby Wright above. Late 1911 saw the establishment of the Naval Flying School and the birth of the Royal Naval Air Service. Finally operated by the RAF until 1947, the site is now occupied by three prisons.

Warden Point marks the eastern end of the distinctive red clay cliffs that form the major part of the northern coast of the Isle of Sheppey. Their soft nature means that they are subject to continual erosion. (A. L.)

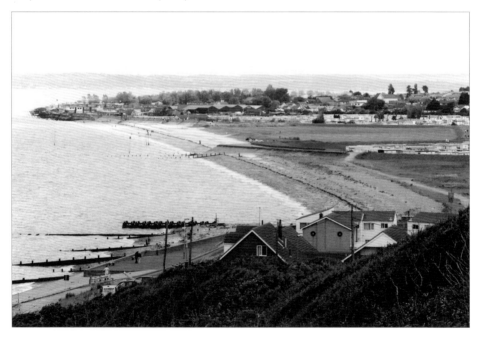

Beyond Warden Point the land becomes flat as Leysdown is approached and continues thus down to the island's extremity at Shellness. Static caravan parks have increased considerably in number here since the last war. In the distance can be seen the far side of the Swale and the hills behind Whitstable. (A. L.)

In contrast to its western entrance at Queenborough, the eastern end of the Swale is a ¾-mile-wide stretch of water, but the navigable channel is both shallow and very narrow. On this blustery day in October 2001 the paddle steamer *Kingswear Castle* was making the trip to Whitstable from Strood Pier, a lengthy voyage for the 6-knot vessel, which therefore was made only once a year, usually to meet the *Waverley*. (A. L.)

On a calmer summer day, the 82-foot sailing barge *Mirosa* makes her leisurely way eastward in the same position as the *Kingswear Castle*. *Mirosa* accommodates up to twelve passengers for sailing trips. It was here that the Harty Ferry used to connect the mainland with the island up until the last war. 'At low tide there are innumerable gulls, curlews and other birds, and these the wayfarer may well have time to watch if delayed as I have been for over an hour by thunder, hail and wind, that made the return of the boat impossible.' Walter Jerrold, 1907. (A. L.)

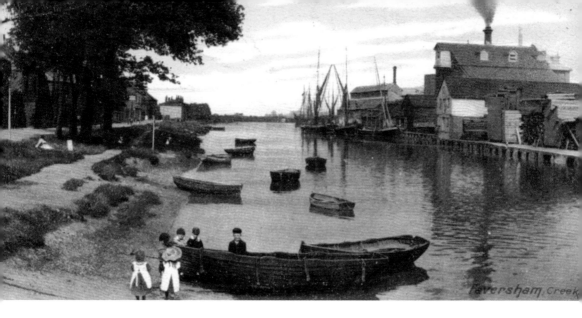

Served by its tidal creek, Faversham was once a thriving small port. There were also gunpowder factories in the area, which suffered their share of disasters. Nowadays the only industry is brewing. This early view of the creek shows Front Brents at left and the Shepherd Neame Brewery and a timber yard at right. The children in the foreground seem to enjoy messing about around boats, something which would not be encouraged today.

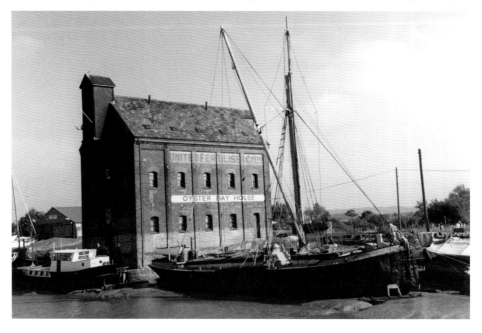

The creek nowadays is home to a varied collection of craft, including the sailing barges *Ironsides*, *Orinoco*, *Mirosa*, *Greta*, *Henry* and *Repertor*, retired from commercial life. This example, possibly the *Decima*, was in 1998 moored close to the now privately-owned Oyster Bay House, a reminder of when these shellfish were caught by a whole fleet of smacks from Faversham and Whitstable. More recently, Everard's spritsail barge *Cambria* was completely rebuilt here. (A. L.)

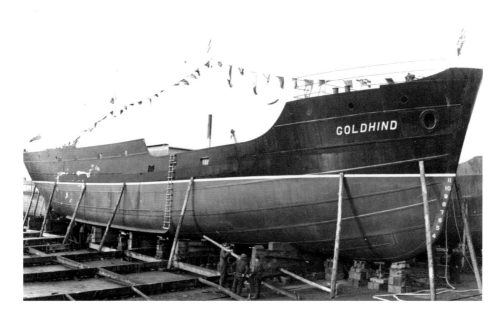

Commencing in 1916, James Pollock & Sons built ships at Faversham for more than fifty years. Tugs, service craft and coasters were regularly launched sideways into the creek, the *Goldhind* being typical of the coasters built in the immediate postwar years. Other vessels were the coaster *Camroux II*, tug *Lobe* for London Rochester, the coastal tanker *BP Haulier*, and the tugs *Sun III*, *Sun XXIV* and *Sun XXVII* for service on the Thames. (James Pollock & Sons)

This recent view in the direction of the site of Pollock's yard shows the extent of the new housing that has been built to overlook Faversham Creek. (A. L.)

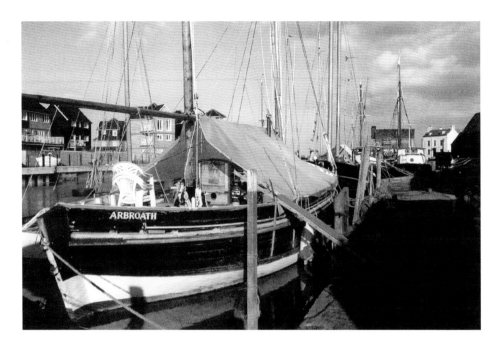

Standard Quay is a popular place for mooring traditional craft. It retains its historic buildings and the whole creates an atmosphere redolent more of the nineteenth century. Only when one's glance shifts to the far side of the creek is a feeling of harsh modernity restored. (A. L.)

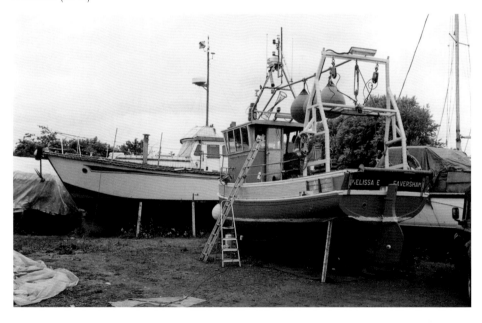

Peter Dodds and his partner Alan Reekie purchased the land to create Iron Wharf Boatyard twenty-five years ago from British Railways. It was chosen primarily to provide moorings for their barges *Mirosa* and *Ironsides*. Since then it has expanded to accommodate a great miscellany of craft in various states of repair within an almost rural environment. Each corner of the yard presents a new vista. (A. L.)

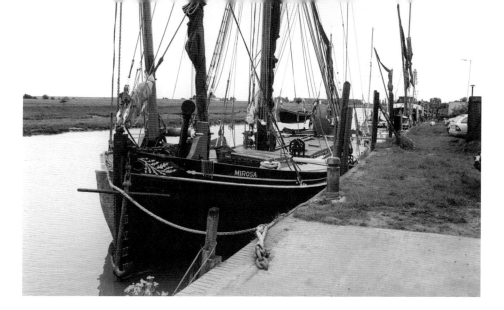

Built in 1892 at Maldon as the *Ready*, the spritsail barge *Mirosa* originally carried hay, straw and timber between London and the ports and rivers of Essex, Kent and Suffolk. Purchased by Francis & Guilders in 1930, she traded commercially until 1965. Trinity House requested her name for a new lights tender in 1947 and so she became *Mirosa*. Peter Dodds purchased her in 1976 and afterwards brought her to Iron Wharf boatyard. (A. L.)

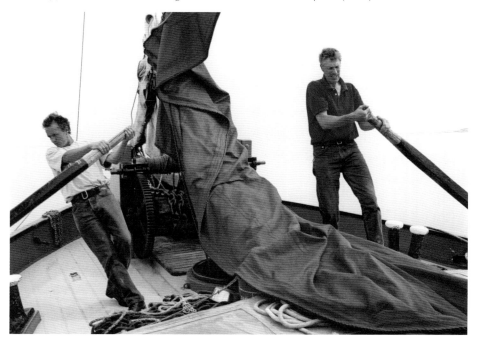

Unlike most of the local barges, *Mirosa* has no engine and if the wind drops, 'sweeps' have to be employed to maintain steerage way. Mate Geoff Ingle, left, and Master Peter Dodds use their maximum efforts to keep *Mirosa* moving in the Swale in August 2002. Geoff arrived on a boat from Gibraltar and stayed. He is usually known by his nick-name 'Frog,' the name of his earlier boat, and now owns and sails the similar barge *Orinoco*. (A. L.)

Among the interesting pubs found along the north Kent coast, one that deserves description is the Shipwright's Arms at Hollowshore (earlier Holy Shore). It lies at the junction of Faversham and Oare creeks, near to where they enter the Swale. Mostly of clapboard construction, the building is well over 300 years old and was first licensed in 1738. This view probably dates from the 1930s. (Derek Cole)

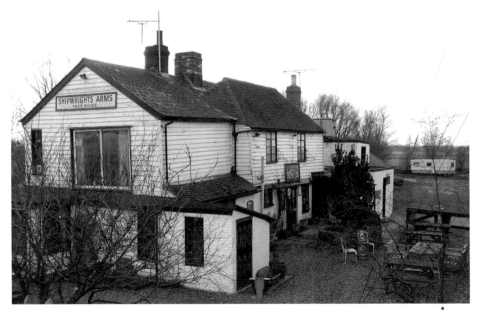

This recent view of the Shipwright's Arms free house shows its various extensions. At one time it was a revenue cutter station but later served pirates and smugglers as well as local sailors and fishermen. 'Feminine comforts' were no doubt available in those earlier years. Its low-lying position renders it exposed to very high tides and it unfortunately suffered flooding in December 2013, but has now re-opened. (Derek Cole)

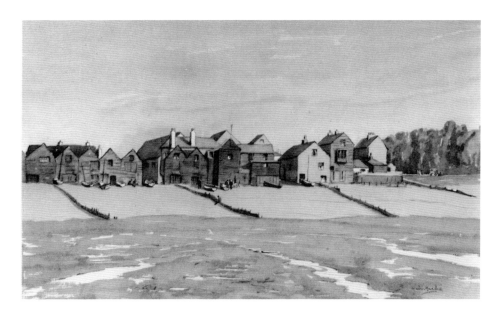

Leaving behind the creeks of the Swale and returning to the coast, a short distance further east lies the picturesque harbour of Whitstable. Famous since Roman times for the oyster fishery, its harbour gained importance when the railway was opened from Canterbury. Many of the shoreside dwellings and fishermen's sheds were earlier built of wood, as indicated in this drawing by Martin Hardie.

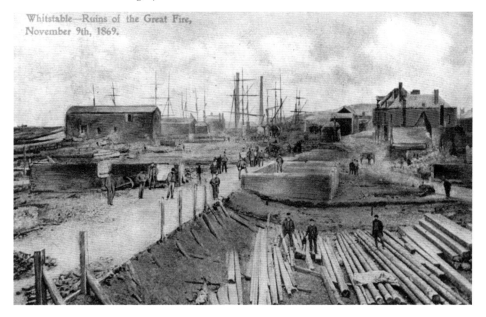

Whitstable—Ruins of the Great Fire, November 9th, 1869.

So many wooden buildings constructed in close proximity inevitably increased the chance of a serious fire and unfortunately a large area west of the harbour was lost in November 1869. Termed the Great Fire, it consumed more than seventy buildings between Sea Street and the harbour, twenty-five of them inhabited houses. Along Marine Street alone losses included the Victoria and Spread Eagle inns, thirty-six stores, sixteen cottages, three sail lofts, a blacksmith's forge, one auction mart and three shoemaker's shops. (W. J. Cox)

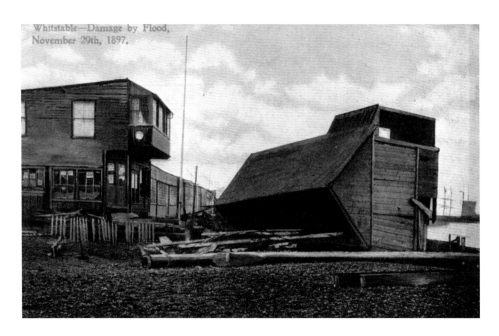

Whitstable—Damage by Flood, November 29th, 1897.

Disaster could also be caused by the sea, for Whitstable was situated on a lee shore, facing the frequent northerly gales of the Victorian period. One major storm occurred on 29 November 1897, creating havoc from Margate to Sheerness and beyond. At Whitstable many of the wooden shore-side buildings were wrecked, including the Old Neptune pub west of the harbour and this building to the east near the Hotel Continental. (W. J. Cox)

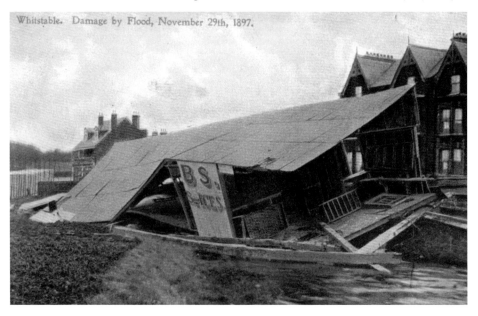

Whitstable. Damage by Flood, November 29th, 1897.

Another loss to the same storm was Gibbs' tea room, sited in the extension to the coal yard on the harbour. Waves coming over the wall lifted the booth off its brick foundation and moved the remains some 20 yards inland. Around the harbour, a whelk store was also demolished and numerous oyster fishermen's stores collapsed. There was also much flooding in the town. (W. J. Cox)

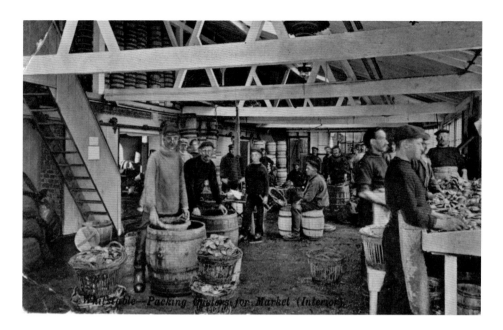

In spite of these setbacks, a sizeable oyster fishing fleet continued to operate from the port and around 1901 up to 100 smacks could be seen offshore. The Whitstable-built yawl *Favourite* of 1890 remains ashore today as a monument to these craft. Others are still sailed as private yachts. Andy Riches, with his boat *Misty*, fishes alone nowadays solely for oysters, a great contrast to this view of oysters being packed for market at the start of the twentieth century. (W. J. Cox)

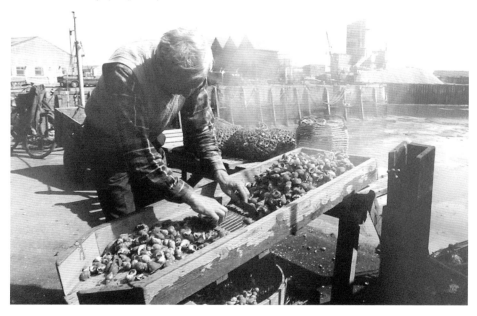

Whelks are still caught in plentiful quantities at Whitstable. They have been trapped in pots since the arrival of men from Sherringham in the 1890s. Here, they are seen being graded and sorted in the 1970s. Stainless steel has since replaced wood for all the equipment used to process these shellfish. (Derrick West)

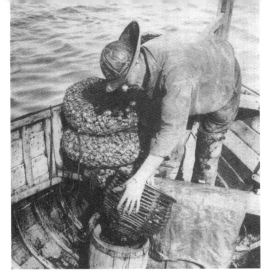
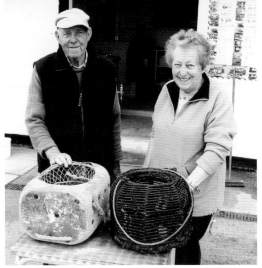

Tom Taylor is seen above left, emptying a whelk pot into a wooden barrel aboard his boat in the 1920s. The pots consisted of an iron frame, around which was wound tarred rope at regularly spaced intervals. A further outward facing net, termed a 'crinny', was placed in the neck of the pot to prevent the whelks from escaping. Pieces of crab were usually placed inside as bait. At right, Derek and Jean West of West Whelks compare a modern 'home-made' pot consisting of a plastic drum weighted with cement with the traditional version. Ten pots were normally secured to a 'shank' of rope, with a weight at each end.

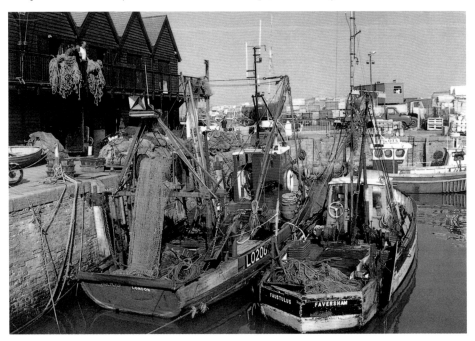

The wooden buildings still house the whelk stores but these are modern replacements of the earlier storehouses. In this view from around 1990, two fishing boats are moored to the quay, while a third, the *Speedwell*, which also served as the local pilot boat, lies adjacent to the timber yard on the west quay. Timber is no longer imported and this area is nowadays mostly allocated to maintenance craft and equipment for the Kentish Flats wind farm. (J. Cates)

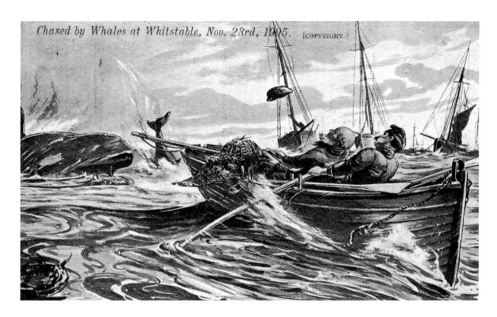

The risks did not end with the threat of fire and storms at sea, for the sea's creatures could prove difficult at times, as experienced by these fishermen in November 1905. One of the whales finally beached itself and was measured before a large crowd of spectators. Such unexpected catches added to the income of the fishermen and longshoremen. (W. J. Cox)

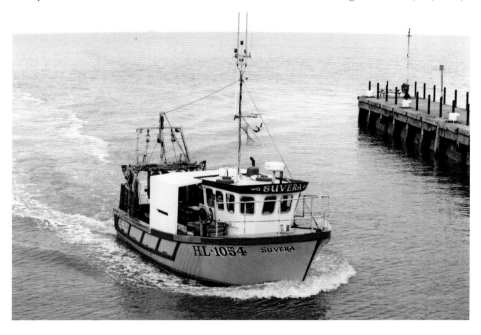

Under calmer conditions, Roger Cooper's fishing boat *Suvera* enters harbour in 2010. It is now mainly sailed by his two sons. Although the only commercial cargoes now imported are roadstone and related products for Brett's Tarmacadam plant, fishing still plays an important part in the economy of the harbour. Despite the decline in the oyster fishery, whitefish, cockles, mussels, crabs and other shellfish are still caught in quantities off the Kent coast. (A. L.)

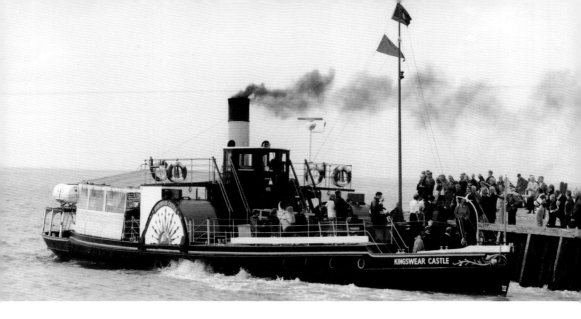

Excursion steamer calls have never been frequent, as the developing resort of Herne Bay to the east captured that trade. The *Kingswear Castle* is here seen leaving the harbour after one of its very occasional calls on a round trip from Strood in October 2001. This paddle steamer returned to its original home on the Dart in 2012, so sadly she may never again be seen in the Thames and Medway. However, Steve Norris with his Thames sailing barge *Greta* offers day sailing trips for up to twelve passengers during the summer. (A. L.)

Although there are few facilities for pleasure craft in the tidal harbour, westward along the beach there is a thriving yacht club. It began as the Kent Yacht Club in 1904 but the name was changed to Whitstable Yacht Club two years later. Their present base on Sea Wall was previously the rebuilt Victoria Inn. Close by is the RNLI lifeboat station, dating from 1963. (A. L.)

Whitstable Harbourmaster Mike Wier served at sea for twelve years before he moved into harbour management, spending roughly equal periods of ten years at Torbay and Sullom Voe in Shetland. He thus brought a wealth of experience to an attractive harbour where commercial marine activity is important but where there is also rapid growth in the leisure amenities, due to the popularity of the port with the public. (A. L.)

Many different coasters and short sea traders have visited Whitstable over the years. The owners of such vessels have also been numerous, many having failed in the bleak years of low returns for coastal cargoes. London Rochester, Lapthorns, Coastal Bulk, Armac Shipping; even Everard's name has almost disappeared. In this picture, two of Lapthorn's ships that had passed to Armac lie moored in the West Quay lay-by maintenance berth around 2010. (Mike Wier)

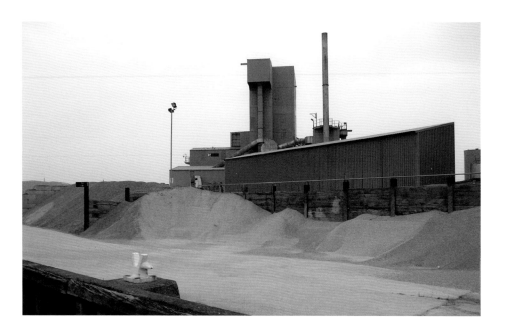

Rather like a warship successfully riding a rough grey sea, Brett's Tarmacadam plant on East Quay remains the only industrial concern in the area, and while potholes occur in the local roads, it seems assured of a future. Tarmac has been made at Whitstable from bitumen and various aggregates, mostly granite, since 1937, but most of the present buildings and equipment date from 1985. (A. L.)

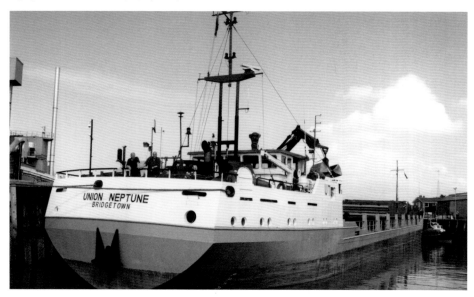

Union Transport Group of Bromley regularly delivered cargoes of granite chips for more than twenty years. The *Union Pluto* and *Union Neptune* were their regular ships, the latter seen alongside the East Quay around 2009. After seventy years of trading, and having absorbed Armac, Union Transport became the latest shipping company to cease trading, in May 2013. Absolute Shipping bought out Union Transport at that time and took over Brett's contract, still bringing in cargo with the former vessel, now renamed *Pluto*. (A. L.)

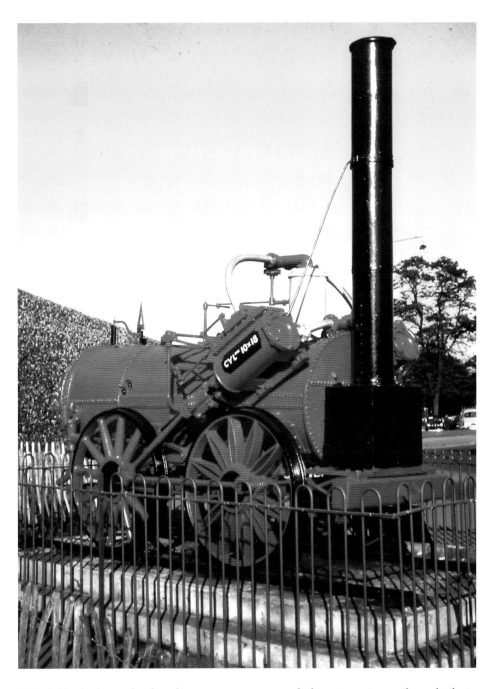

Whitstable harbour developed as a consequence of the pioneering railway built to link Canterbury with the sea. The first steam locomotive on this line was the *Invicta*, built by George Stephenson in 1829, which hauled the first train into Whitstable on 3 May 1830. *Invicta* had 4-foot wheels driven by two cylinders of 10 inches by 18 inches. Sadly, it was underpowered and was retired in 1836, stationary engines providing the required motive power. After the South Eastern Railway took over the line the locomotive was preserved and eventually placed on public view at Canterbury, as seen here in 1966. Further restoration followed and the *Invicta* can still be seen at Canterbury museum. (A. L.)

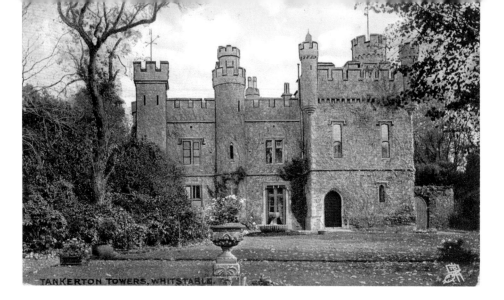

Whitstable Castle was built to the east of the harbour in around 1790 as the Manor House. It was owned by Charles Pearson, who had exploited the copperas deposits (ferrous sulphate) found locally in the cliffs. Around 1830, his son Charles Jnr sold the estate to Wynn Ellis, a cousin by marriage, Liberal MP and a flamboyant character who lived there from 1836 with his mistress, Susan Lloyd. The building was called Tankerton Towers. (Raphael Tuck)

After Ellis's death in 1875, the building passed through various hands, including those of papermaker Albert Mallandain in the 1920s. He added the oak-panelled billiard room that today is kept for ceremonies. Numerous extensions have been added to this folly over the years, some apparent here. Purchased by the local council in 1935, the building afterwards declined until a major £3-million restoration project was undertaken in 2008. It now provides a first-class venue for wide-ranging public use, situated amid beautifully landscaped gardens. (A. L.)

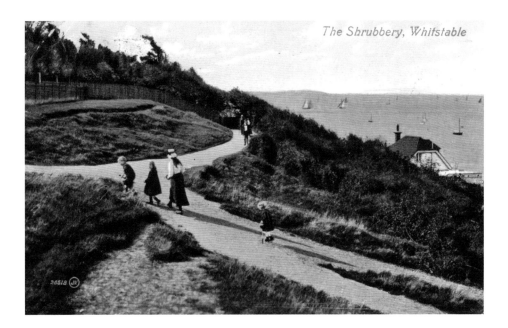

In Edwardian times visitors took their recreation at the Shrubbery, where Tower Hill meets Marine Drive. The Tankerton Hotel, nowadays converted into flats, stands nearby. Little remains of the Shrubbery today but the area still affords an excellent view of 'Whitstable Street' at low tide. (Valentine's Series)

The sandy spit of 'Whitstable Street' stretches northwards for about half a mile from the western end of Marine Parade. Many years ago Roman remains were discovered at the northern end of what was once thought to be a drowned Roman road, but later these finds were considered to be the result of an ancient shipwreck. Beach huts have been a popular feature here for many years. (A. L.)

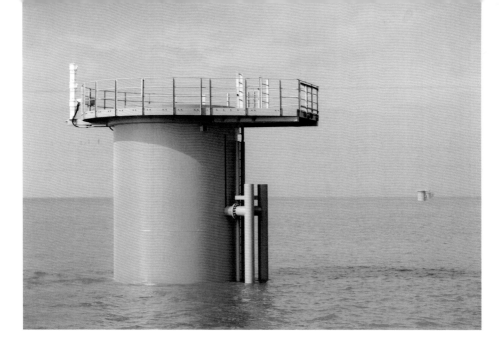

From ancient times we move to the most recent. When completed in 2005, the Kentish Flats wind farm was the first offshore project of its kind in the county. A monopile base of one of the thirty turbines is seen during their construction. The finished wind turbine has a height of 115 metres and each can generate up to 3 mw of electricity. At present fifteen more turbines are being added to this farm. (A. L.)

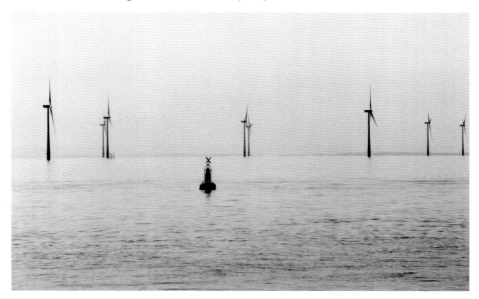

The abundance of sandbanks in the Thames Estuary has led to other wind farms being built. Now added to the Kentish Flats farm, seen here, are the Gunfleet (forty-eight turbines) off Essex; the Thanet farm (100 turbines); and the London Array (175 turbines) on the Long Sand about 9 miles north of the Isle of Thanet. The last named, completed in 2012, is at present the largest in the world and can generate enough electricity to power some 500,000 houses. Their visibility varies with the light and sea conditions. (A. L.)

Returning to the land further east, Hampton was a prosperous separate village in mid-Victorian times but housing development has now joined Tankerton to Herne Bay. The Hampton Inn, in the background, was opened in 1867 as the Hampton Oyster Inn by a local oyster fishery company, but it is now owned by Shepherd Neame, who renovated it in the 1980s but lost the Oyster name. Cliffs and shore defences provide ideal environments for plants such as the vivid Red Valerian, which, with Alexanders and Tamarisk, is among the more common flowers to decorate wild places in this region. (A. L.)

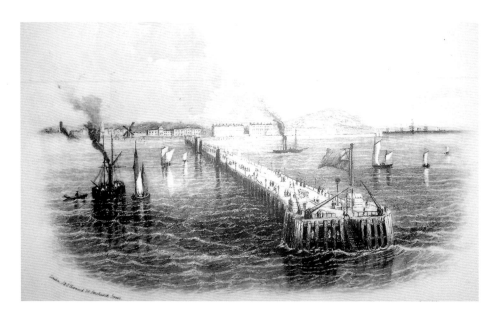

Built at a cost of some £50,000, Herne Bay's first pier was opened on 4 June 1832. It was well over half a mile in length, a distance necessary to allow steamers to call at all states of the tide, the *Venus* being the first vessel to arrive, on 12 May. The pier proved a great success, for by 1842 more than 50,000 visitors were using it. Unfortunately, the use of inferior materials in its construction led to its closure in 1862 and demolition in 1871. (J. & E. Harwood)

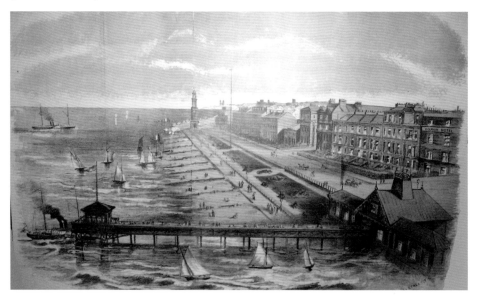

The second pier measured only 415 feet in length initially. This edifice was opened by the Lord Mayor of London on 27 August 1873. It offered very limited access to steamers, so a wooden pavilion with a concert/assembly room was added across the entrance in 1884, in order to increase its popularity. This illustration shows the pier around 1893, before work was started to lengthen it to 3,787 feet, a project that was begun in 1896 and completed in 1899. (Herne Bay Museum)

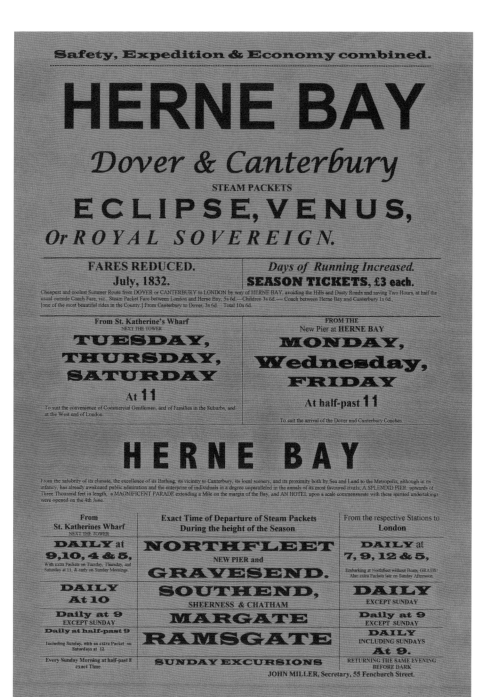

Once the first pier at Herne Bay had been built, steamers from the Thames and Medway were able to call regularly on their way to Margate and Ramsgate. Passengers could also disembark at Herne Bay to board a coach bound for Dover, a route that avoided the rough waters often encountered in rounding the North and South Forelands. This poster of 1832 is a computer-generated copy of a damaged original.

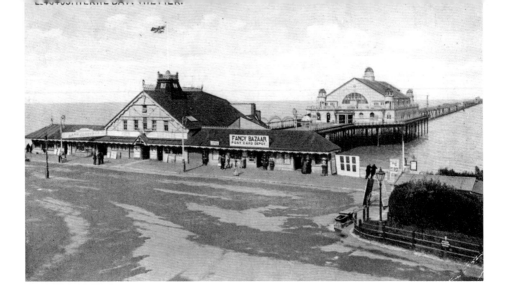

A Grand Pavilion was added to the extended pier in 1910. Besides providing a venue for the usual seaside shows, it also allowed roller skating and, more unusually, provided a home for a famous hockey team. This view shows the earlier entrance pavilion and adjoining shops in the foreground and the later Grand Pavilion at the rear. Sadly, as so often occurs, the former was destroyed by fire on 9 September 1928 and the latter by the same cause on 12 June 1970, during refurbishment. (Photochrom Company)

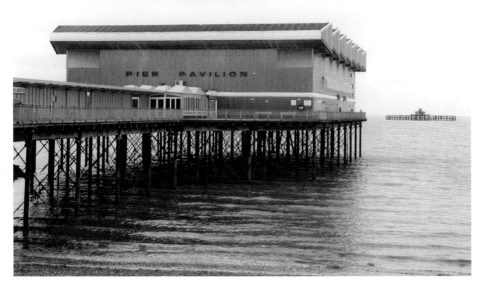

Canterbury City Council took over the pier in 1971, replacing the Grand Pavilion with this sports hall and leisure centre of modern design in 1976. The landward side of the pier was strengthened to allow access to this new £1 million building but the rest was not and the major storm of 31 January 1978 caused the outer part to collapse, leaving the head isolated at sea. This last pavilion in turn became unsafe, leading to its demolition in 2012, the pier being retained. (A. L.)

Situated opposite the Connaught Hotel, the central bandstand was completed to a design by H. Kempton Dyson in 1924. Intended for military brass band concerts, it immediately became popular and was fully enclosed by a southern frontage in 1932. It remained a focal point on Herne Bay's seafront until the 1980s, when it came close to demolition. However, public opinion prevailed and it was fully restored during 1998–9.

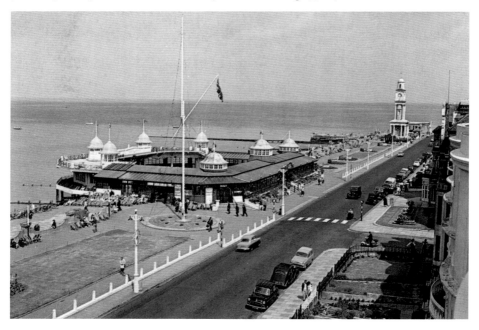

The Central Bandstand in its enlarged form in the 1950s. By the 1990s the Connaught Hotel had become the Harbour Café Bar, but nowadays it houses the Connaught Bingo Club. (Noel Habgood)

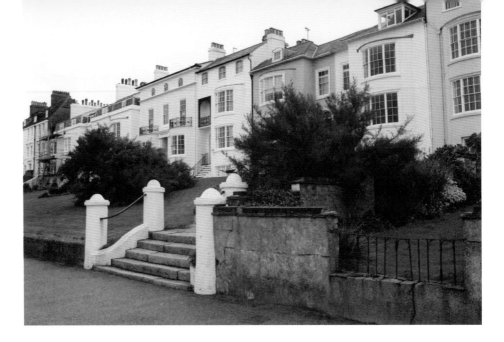

A recent view of the east end of Central Parade, which formed part of the old town of Herne Bay. Most of this attractive terrace was built by 1820 and lies close to the Ship Inn, out of sight to the left in this photograph. The Ship dates back at least to the seventeenth century and although it has suffered closure in recent times, remains the oldest pub in Herne Bay. (A. L.)

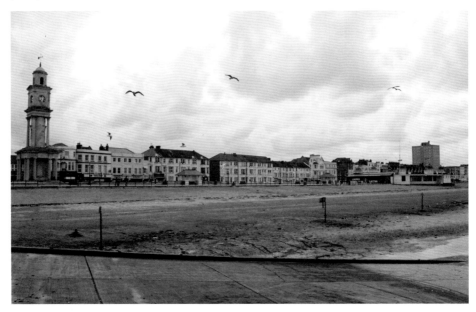

This atmospheric low-season photograph taken from the breakwater shows the stretch of the Central Parade between the clock tower and the remains of the pier. The 80-foot clock tower dates from 1837, the year of Victoria's accession to the throne, and was a gift of wealthy Londoner Mrs Ann Thwaytes. There are similar towers at Margate, Sheerness and Gravesend but this was the earliest of its kind. (A. L.)

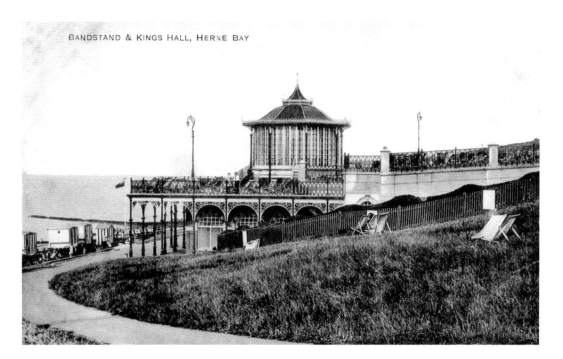

Beyond the Central Parade, the Downs lead towards Beltinge Cliff and finally Reculver, 2 miles or so distant. On East Cliff Parade lies another place of entertainment, King's Hall. When opened in July 1913 it was the King Edward VII Memorial Hall, but soon took the shorter title.

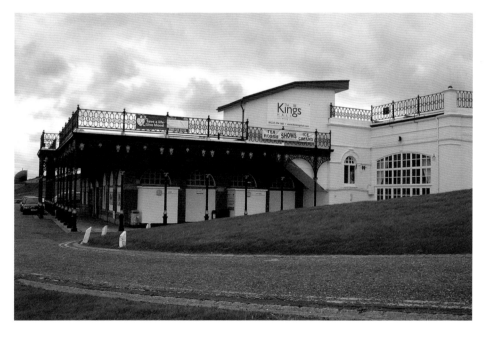

Fortunately this venue, with its delicate iron columns, has been preserved. It still has many original Edwardian features but the elegant earlier bandstand on the upper level shown in the photograph above has been lost. (A. L.)

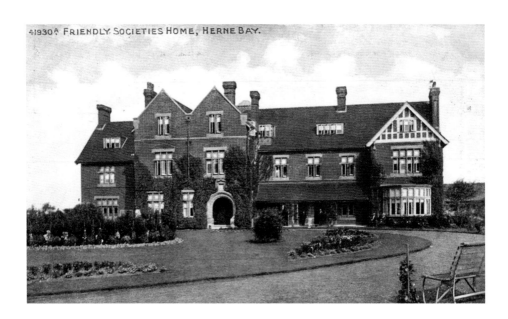

As popular as the east Kent Coast became for healthy holidays, its bracing climate also made it a Mecca for the sick. In the late Victorian years numerous convalescent homes were built, two in Reculver Road, Herne Bay. Philanthropist Passmore Edwards offered to build this home for the Friendly Society, initially for fifty patients. The foundation stone was laid in November 1897 but the accommodation was subsequently extended to 135. Sexton Snell was the architect. (Photochrom Company)

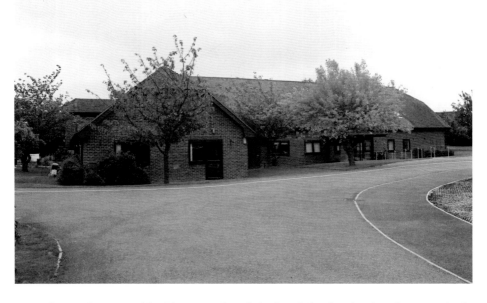

Around 1990 the original building was demolished and this low-level replacement built. By 2009 it was no longer viable and it was consequently sold to Age Concern (now Age UK), who carried out a complete refurbishment The result is a modern-day centre where the elderly can meet that provides general advice, meals on wheels, and a laundry. It additionally caters for dementia sufferers. (A. L.)

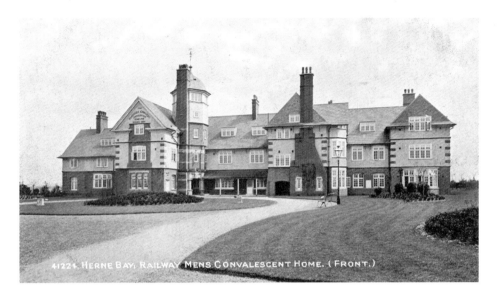

The first railwaymen's convalescent home was built next door under the direction of the same architect; it was the idea of John Edward Nichols, cashier of the London, Chatham & Dover Railway. Rather than the railway, Passmore Edwards was again the major benefactor, but not without reluctance. The building was opened in June 1901 with 100 beds. It became very popular, a 14-day stay being available free of charge. This picture probably dates from the 1930s, by which time considerable extensions had been made. (Photochrom Company)

The railwaymen's home was so popular that there were eventually another nine. Some 41,520 railwaymen had visited Herne Bay alone by the time of its golden jubilee in 1951 and in the years immediately after the war some 7,000 were arriving annually. Numerous pictures were taken of the residents. The end of the steam era in the 1970s saw declining numbers, leading to the sale of the home. It eventually became Elliott House, which nowadays caters for about seventy dementia patients. (F. Simmons)

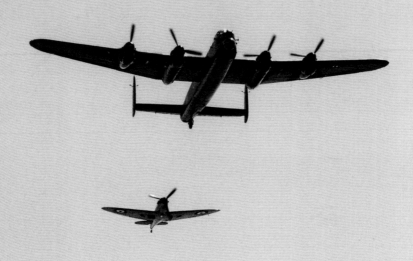

The ancient site of Reculver lies just a short distance along the coast. Roman in origin, the fort guarded the northern entrance to the Wantsum Channel, separating the Isle of Thanet from mainland Kent. In 1943 the shoreline was used for testing Barnes Wallis's bouncing bomb, used to breach the German dams. The above photo shows a Lancaster bomber and a Spitfire flying along the Kent coast, symbolic both of the Dams Raid and the Battle of Britain, which was fought in the skies above Kent in 1940. (A. L.)

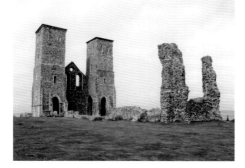

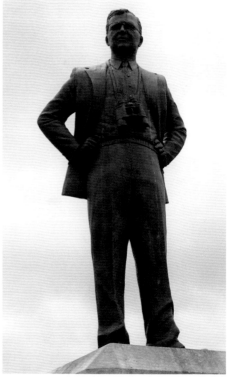

Above: The twin towers of the ancient St Mary's church at Reculver, restored by Trinity House; they are all that remain of the building, which was dismantled early in the nineteenth century.

Right: The bronze statue of Barnes Neville Wallis by American sculptor Tom White that was erected near the King's Hall in Herne Bay in 2008. A miniature version of the bouncing bomb is exhibited in Herne Bay museum. (A. L.)

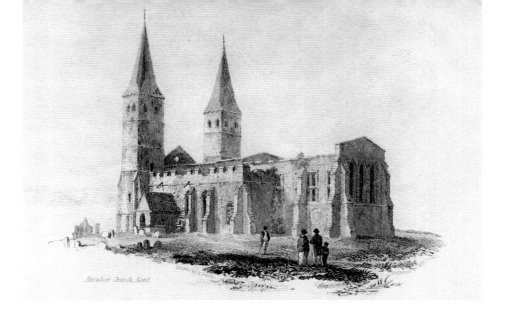

Reculver Church, Kent.

The site of the earlier Roman fort of *Regulbium* is one of great interest. After the Romans left around AD 360, there is a story that King Ethelbert converted the praetorium into a palace in the year that St Augustine arrived at Canterbury, AD 597. A monastery was completed by AD 669, Abbot Berhtwald becoming Archbishop of Canterbury in AD 692. The church or minster dates from this time, with the twin towers probably added in the twelfth century. This view dates from 1800, when the church was in decline.

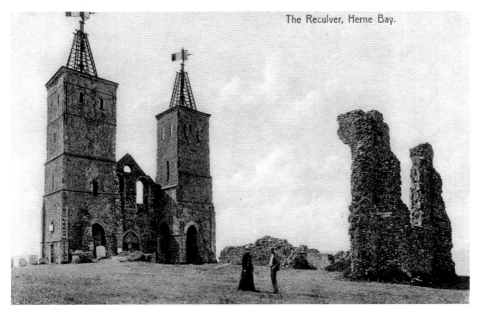

The Reculver, Herne Bay.

In 1805 a rash young incumbent persuaded his parishioners to demolish the church, which had a substantial amount of Roman material and Anglo-Saxon features. Most of the stone was then removed for use as building material, except for the twin towers, which were purchased and restored by Trinity House in 1810 as a seamark, twin wind vanes replacing the spires when they were blown down before 1819. The vicarage of the church became the King Ethelbert Inn. (F. G. Holman)

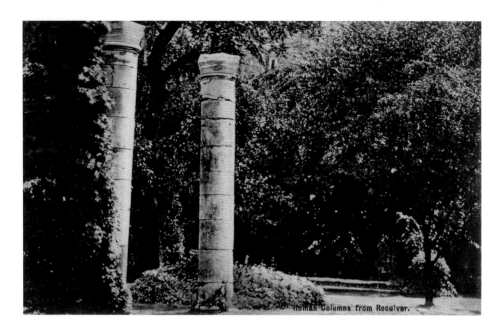

Two columns situated in the original Roman governor's house and later located in the same church were apparently sold to a local farmer as rollers at the time of its demolition. Fortunately, they were saved by a Mr Sheppard, who arranged for them to be placed in the precincts of Canterbury Cathedral. (F. G. Holman)

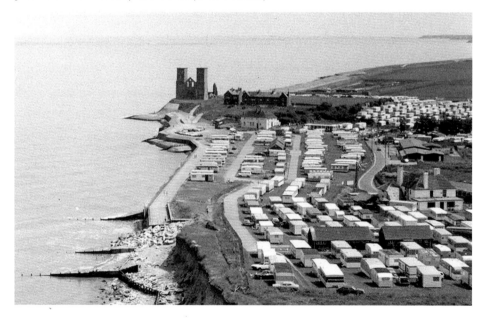

This aerial view of Reculver shows its exposed position and how more than half of the original site has been lost to sea erosion. On the land side it has been encroached upon by numerous caravans and mobile homes, a feature which is common also to the area east of Whitstable and the north of the Isle of Sheppey. The coastguard cottages to the right of the towers were demolished some thirty years ago, leaving the King Ethelbert Inn as the only building to survive in the vicinity. (Ted Ingham)

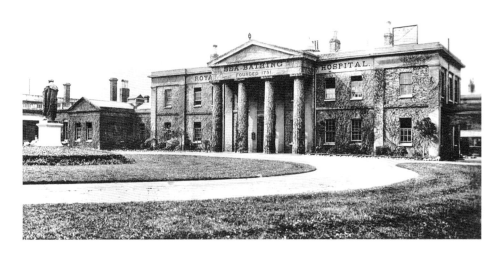

Our last visit is to Margate, where the Royal Sea Bathing Hospital overlooked the sea at Westbrook. It was the brainchild in 1791 of Quaker physician John Coakley Lettsom, who believed that sea air and salt water bathing could be beneficial in the treatment of tuberculosis. It opened with thirty beds in 1796 and by 1841 over 200 patients were accommodated, many of them children. RCS President Sir Erasmus Wilson, whose statue appears at left, gave £30,000 towards its enlargement in 1882, including the building of the chapel. The Greek portico came originally from Lord Holland's house at Kingsgate.

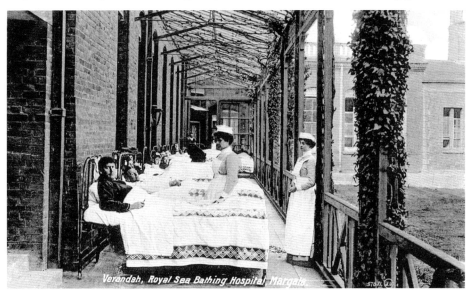

Verandah, Royal Sea Bathing Hospital Margate.

Tubercular disease was still treated there up until 1950, after which the hospital catered for a variety of medical cases. Patients were regularly placed outside on verandas. Karl Marx spent a month there being treated for 'boils' in 1866. The hospital closed finally in 1996 after 200 years of treatment of countless patients (over 50,000 had been treated by 1920). The buildings were subsequently sold to private developers and converted to private residences. (Valentine's series)

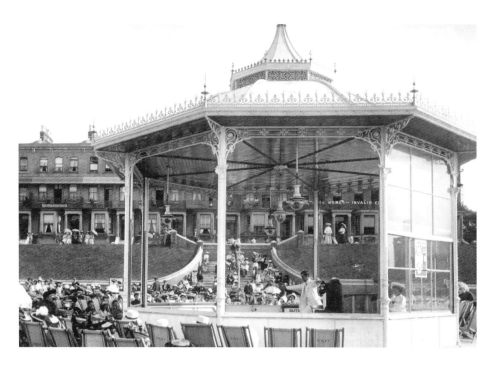

This elegant Victorian bandstand was situated a short distance from the Sea Bathing Hospital, along the promenade completed in 1901. It was one of three, the others being at the Fort and the Oval; only the last named remains today and that is a replacement. Sea View Terrace, at rear, now overlooks a mini golf course.

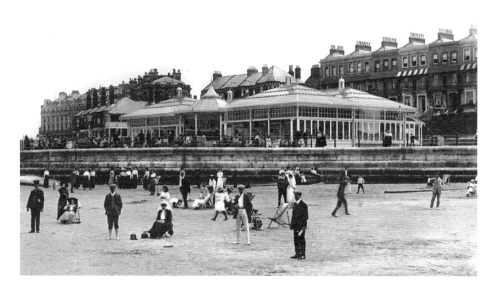

The much grander Westbrook Pavilion replaced the above bandstand in 1909, providing a successful venue for numerous entertainers until it was wrecked by the major storm of 31 January 1953 and never replaced.

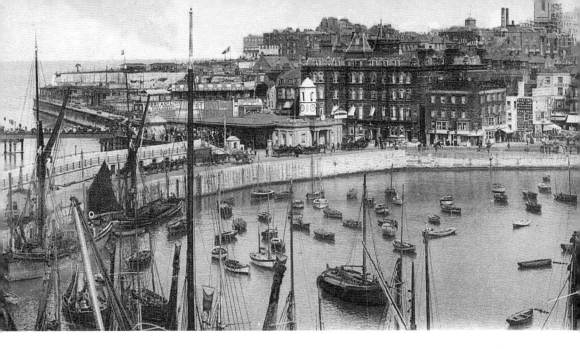

Margate Harbour, seen from the pier lighthouse during the Edwardian period. Today, only the Droit House, at centre, remains of the significant buildings of the time, and that was rebuilt after being largely destroyed in the last war. The Ship and Metropole hotels, Seaman's Institute and lookout, Cobb's Brewery and Holy Trinity Church have all gone, as well as most of the boats. (Louis Levy)

Modern Margate harbour has lost some of the character of earlier years. The buildings at the centre represent old Margate, including the Benjamin Beale pub, now The Hoy, the old Parade Cinema and those at the corner of King Street, together with the Royal York Mansions at right. Most recent is the Turner Contemporary gallery, partially hidden by the Shell Lady in the foreground. This 2007 sculpture by Anne Carrington represents Mrs Sophie Booth, Turner's widowed landlady and confidante during his residence at Margate. (A. L.)

7 miles offshore from Margate lies the Tongue Sand, a hazard to shipping in years gone by. In June 1942 a Maunsell anti-aircraft fort was placed there as part of the defences of London. It was one of four manned by naval personnel, the others being at the Sunk Head and Roughs, off Harwich, and Knock John, off Herne Bay. As built, they could accommodate 120 men in the two pillars. The armament of HM Tongue Fort consisted of two 3.75-inch AA guns and two 40-mm Bofors. On 5 December 1947 the fort showed signs of collapse in a storm and lost its landing stage.

 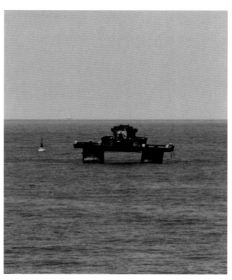

The damaged fort is seen from the side at left, showing the listing pillar. Those remaining aboard, now reduced to four, were taken off by the Margate lifeboat, there being just sufficient time to also rescue the contents of the wardroom drinks store. No record exists of this reaching the shore, but the bad weather delayed the boat's return. Due to its presumed instability, the fort was abandoned and eventually stripped of its armament and fittings. It is seen at right a short time before its final collapse in February 1996. (A. L.)

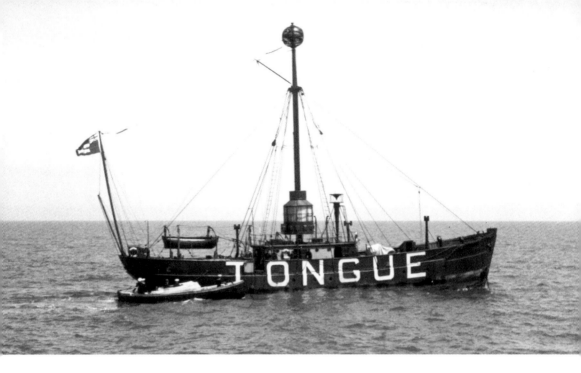

The Tongue light vessel was situated 9 miles north of Margate, assisting vessels to avoid the Tongue sandbank and guiding them towards the Prince's and Edinburgh Channels. Various vessels were moored on the Tongue station between 1848 and the withdrawal of the last automated version in 1988. This picture was taken during an inspection by the Elder Brethren of Trinity House in September 1934, the lantern being lowered for that purpose. (Sir David Wilson Barker)

A rougher sea greets the relieving crew at the Tongue station in around 1963. Post-war steel light vessel No. 12, with an electric main light, was a great improvement on the wooden, oil-lit ships of the pre-war days. A helicopter was employed for the reliefs by 1978 and the crew was finally withdrawn in April 1985, leaving the vessel operating automatically for a further three years before its removal. The picture at right shows the Tongue lightvessel, fitted with a helideck shortly before the vessel was automated. (A. T. 'Reg.' Gibbs)

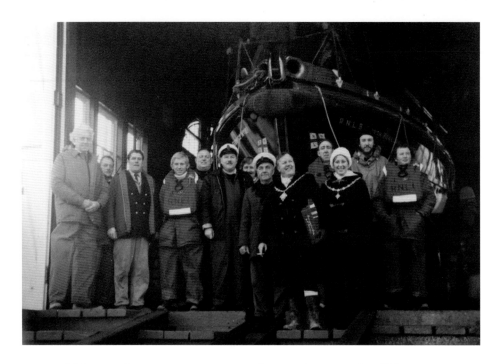

Margate lifeboat made numerous rescues over the years but a popular off-duty exercise was to take the mayor and his guests to the Tongue lightship with the annual Christmas turkey and other gifts. Crew members gather in 1976 before the launch of RNLB *North Foreland* on their mission of goodwill. Those assembled are, from left, Ben Richards, Don Rowe, David Lacey, Mick Baker, John Christian, Alf Lacey, John Watkins, Alf Manning (coxswain), Cllr Dennis Masters (mayor) and his wife, Ken Sandwell (at rear), Chris Sandwell and Peter Barker. (Chris Fright)

A service with carols was usually held on board the Tongue and the vicar would give a blessing to those who had given up their Christmas to serve afloat. Here the light vessel master, possibly Alf 'Tug' Wilson, poses with Councillor John Gwynne Jones and his wife, Mayor and Mayoress in 1974/5, with Reverend Donald Lugg, vicar of St Paul's church, at rear. The weather was not always kind on these occasions and those unaccustomed to the movement of a lifeboat in heavy weather were often laid low by the experience. (Chris Fright)

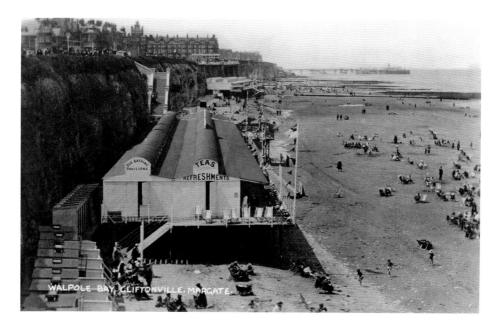

All of the harbours and piers along this north coast of Kent have a history of damage due to the violent storms that have occurred on almost a regular basis over the centuries. Those of 1877 and November 1897 were well recorded, the latter causing havoc from Sheerness right down to Margate, where nine of the crew of the surf lifeboat were drowned when it capsized. This view of the cafés at Walpole Bay shows how inviting the beach appeared in summertime.

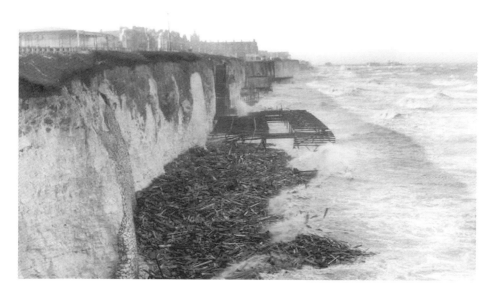

A large amount of bad weather occurred in the immediate post-war years. Mounds of seaweed accumulated on the beach and in the gapways, rapidly brought ashore by ex-army lorries to be spread on the farmland. Finally, in 1953, the 31 January storm flooded Margate and many acres inland between Reculver and Birchington. Along the coast nothing could withstand the force of wind and wave, the cafés above being reduced to matchwood.

Acknowledgements

A book was published by T. Fisher Unwin in 1911 entitled *The Kent Coast*, part of the County Coast Series. Written by Arthur D. Lewis, it gave a detailed account of the history of the coast up to that date, quoting also from many earlier works by distinguished authors. Although long out of print, it remains a valuable work today for the information it provides about the county of a century ago, but the relatively few monochrome illustrations included do not adequately portray the variety of the towns or topography of the region.

I have in contrast given prominence to illustrations, which results in far less text than in Lewis's work, but I hope there is a sufficient amount to inform and also to encourage enthusiasts for the subject to enquire further on this very varied region. There are many other works that relate in some way to the north Kent Coast. Regarding the history of naval operations, two of importance are *Sheerness Naval Dockyard and Garrison* (2002) by David T. Hughes and *Sailor in the Air, Memoirs of the World's First Carrier Pilot* by Richard Bell Davies, published originally in 1967 and reprinted in 2008. The latter work contains numerous references to the Naval Flying School at Eastchurch airfield, as does Air Commodore Bill Croydon's *Early Birds*, published for the Sheppey Heritage Trust around 2006. In relation to fishing, Derek Coombe's *Fishermen from the Kentish Shore* (1989) is also very helpful.

This book compliments my earlier work *Thames-side Kent Through Time* but includes more detail on Gravesend Reach, the Lower Hope and Sea Reach, the last for a long time being the base for oil refineries and now also the site of the new London Gateway container port on the Essex shore. It is interesting to compare my record of the commercial exploitation of Sea Reach with Joseph Conrad's picturesque account of the same stretch of water in *Heart of Darkness*.

Many people have given their kind assistance in the preparation of this book: Stan Rayfield of Queenborough helped with much information about local industry and the Pier. Kevin Beacon of Peel Ports, Medway, together with his Sheerness VTS colleagues have frequently brought me up to date with the changes to shipping and commerce of the River Medway, as has harbourmaster Mike Wier in respect of Whitstable. The staff of Blue Town Heritage Centre, Sheerness, and Linda Vine at Queenborough Guildhall Museum gave me every assistance; they are two very interesting local museums, the former housing a music hall.

I am additionally very grateful to those who have helped with postcards and illustrations of earlier days. I have tried wherever possible to acknowledge the original source of these items, or when this is not known, the present owner of such material. My photographs are accompanied by my initials.

The crews of the Medway ship-berthing tugs of, progressively, Knights, Howard Smith, Adsteam, and nowadays Svitzers, have always been very helpful and I particularly thank David Brown, Ron Kite, Paul Kite, Trevor Edgely, Mark Buckley, Tony Lowrie and Peter Riddle. Among the barging fraternity Peter Dodds of *Mirosa* and Steve Norris of *Greta* have given me more information over the years than I could ever compile in a book.